Josiah McElheny
The Past Was A Mirage I'd Left Far Behind

D1088806

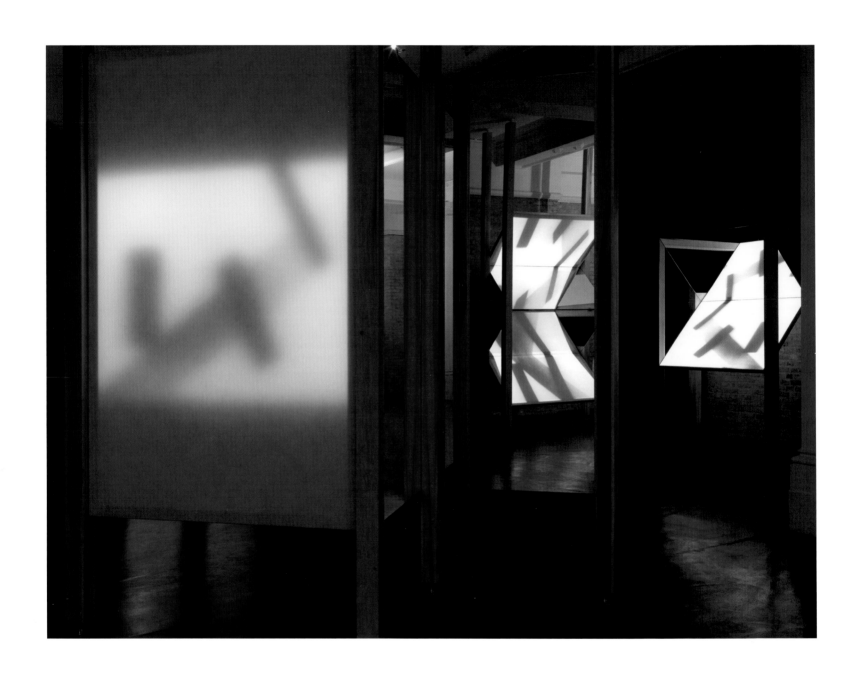

Josiah McElheny
Installation view:
The Past Was A Mirage I'd Left Far Behind, 2011-12
The Bloomberg Commission
Whitechapel Gallery, London

Josiah McElheny

The Past Was A Mirage I'd Left Far Behind

 Whitechapel Gallery

Contents

Sponsor's statement

Bloomberg is delighted to sponsor *The Past Was A Mirage I'd Left Far Behind*, the third Bloomberg Commission at the Whitechapel Gallery. A dynamic partnership that provides an international artist with the opportunity to create a new site-specific work, the Bloomberg Commission reflects our ongoing commitment to contemporary arts initiatives that put innovation and access at their core.

Bloomberg is a global news company that uses technology to connect influential thinkers with ideas and information, and it is particularly exciting to see the way in which Josiah McElheny has responded to the extraordinary history of the former Whitechapel Library in this latest commission. Through his unique network of mirrored sculptures, he uses film, reflection and refraction to inspire a powerful interaction between art, people and ideas. From the invited guest curators of the film programme to the way that visitors view themselves in screens around the gallery, this commission inspires collaboration and engagement on every level.

Bloomberg is committed to helping arts organisations reach new audiences and we are pleased that through the Bloomberg Commission, the Whitechapel Gallery is able to open its doors all year round with free access for all for the first time.

Bloomberg

right:
Whitechapel Gallery, London.
Designed by Charles Townsend Harrison (1901),
with 2009 expansion designed by Robbrecht en
Daem Architecten with Witherford Watson Mann.

Foreword

The Whitechapel Gallery includes the building of the Passmore Edwards Library. Completed in 1896, the former library's façade featured unusually large windows, allowing light and air into a public building designed as a 'lantern for learning'. The ambition to bring enlightenment to all and not just the privileged few ricocheted throughout late nineteenth and twentieth century architecture. It had manifested itself in ideas of truth through transparency and the future as a crystal, ideas that had inspired architects and writers such as Paul Scheerbart or Bruno Taut, whose famous 1914 glass pavilion boldly declaimed: 'coloured glass destroys hatred'.

This essentially modern concept of expressing the aspirations of enlightenment through glass and light provides the leitmotif for the extraordinary work of Josiah McElheny – contemporary sculptor, writer and creator of the 2011 Bloomberg Commission. The commission invites an artist to create a year-long, site-specific artwork, exhibited in and inspired by the former reading room of the original Whitechapel Library. Taking up illumination as an aesthetic and a social project, McElheny proposes the history of abstraction as a hall of mirrors. Seven mirrored, sculptural screens allow for projections of reconfigured abstract films. Refracting and distorting, the sculptures offer reflections on the utopian notions of light, materiality and colour in modernist aesthetics. Working with external selectors for his moving images, McElheny's installation fragments monolithic views of history and challenges traditional concepts of authorship.

We would like to express our continuing appreciation of the support of Bloomberg, whose enlightened generosity allows an artist the chance to develop and create a brand new work of art. Our heartfelt thanks to Jemma Read and Lois Stonock for their faith in bringing works of art into being and enabling visitors to have access to them, for free, over the duration of a year. We would also like to thank Josiah McElheny's galleries, White Cube in London and Andrea Rosen Gallery in New York, for their support and commitment to

the project – especially Jay Jopling, Craig Burnett, Andrea Rosen and Teneille Haggard. The Wingate Scholarship has been a crucial partner in making these commissions happen and our sincere thanks go to Peter Warren, who has helped us to realize Josiah McElheny's vision.

Commissions are not just an opportunity for an artist, but for a whole team to get involved in the conception, production and installation of a new work of art. We are grateful to our colleagues who have worked on the project, specifically Eisler Curator and Head of Curatorial Studies, Daniel F. Herrmann, Gallery Manager Chris Aldgate, Assistant Gallery Manager Patrick Lears, AV Technician Richard Johnson and Research Assistant Habda Rashid. Ashley Elliott and The Whitewall Company were indispensable in producing such an exacting installation, while Assistant Curator Candy Stobbs, Ariella Yedgar and Mark Thomson succeeded in publishing this catalogue. Finally, for his knowledge of glass, his understanding of cinematic, architectural, artistic and urban histories, for his inquisitiveness and curiosity and not least for bringing something so dazzlingly beautiful to the Whitechapel Gallery as *The Past Was A Mirage I'd Left Far Behind*, we are most deeply indebted to the artist, Josiah McElheny. As Bruno Taut would have put it:

With colour and glass greetings,

Iwona Blazwick, OBE
Director

Whitechapel Library, Aldgate East

Bernard Kops

How often I went in for warmth and a doze
The newspaper room whilst my world outside froze
And I took out my sardine sandwich feast.
Whitechapel Library, Aldgate East.
And the tramps and the madman and the chattering crone.
The smell of their farts could turn you to stone
But anywhere, anywhere was better than home.

The joy to escape from family and war.
But how can you have dreams?
you'll end up on the floor.
Be like your brothers, what else is life for?

You're lost and you're drifting, settle down, get a job.
Meet a nice Jewish girl, work hard, earn a few bob.
Get married, have kids; a nice home on the never
and save up for the future and days of rough weather.

Come back down to earth, there is nothing more.
I listened and nodded, like I knew the score
and early next morning I crept out the door.

Outside it was pouring.
I was leaving forever.

I was finally, irrevocably done with this scene,
The trap of my world in Stepney Green.
With nowhere to go and nothing to dream

A loner in love with words, but so lost
I wandered the streets, not counting the cost.
I emerged out of childhood with nowhere to hide
when a door called my name
and pulled me inside.

And being so hungry I fell on the feast.
Whitechapel Library, Aldgate East.

And my brain explodes when I suddenly find
an orchard within for the heart and the mind.
The past was a mirage I'd left far behind

And I am a locust and I'm at a feast.
Whitechapel Library, Aldgate East.

And Rosenberg also came to get out of the cold
To write poems of fire, but he never grew old.
And here I met Chekhov, Tolstoy, Meyerhold.
I entered their worlds, their dark visions of gold.

The reference library, where my thoughts were to rage.
I ate book after book, page after page.
I scoffed poetry for breakfast and novels for tea.
And plays for my supper. No more poverty.
Welcome young poet, in here you are free
to follow your star to where you should be.

That door of the library was the door into me.

And Lorca and Shelley said 'Come to the feast.'
Whitechapel Library, Aldgate East.

Bernard Kops, 'Whitechapel Gallery, Aldgate East'
in *Grandchildren and Other Poems* (London: Hearing Eye, 2000)

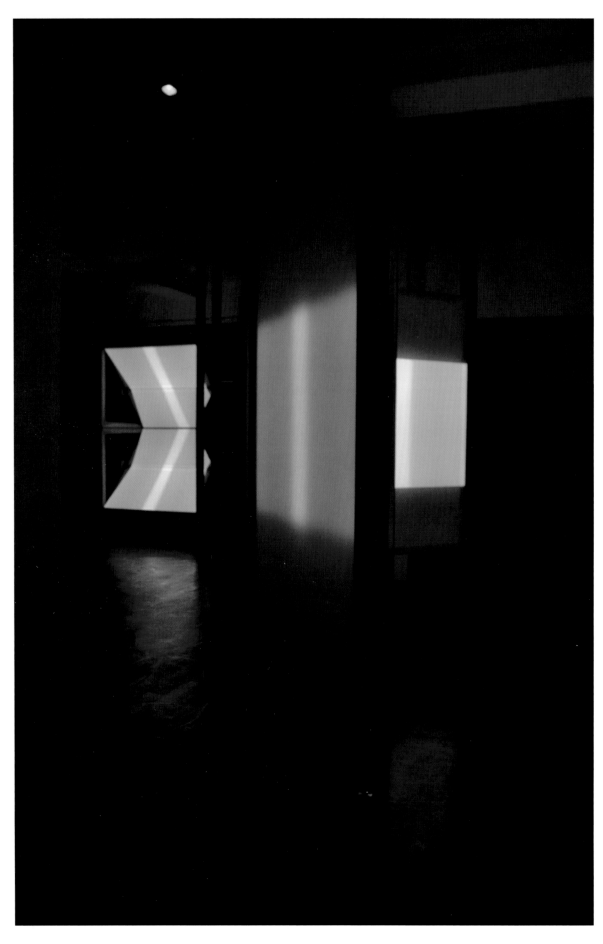

Lisa Le Feuvre

Present Possibilities – The Work of Josiah McElheny

Josiah McElheny's sculptures are formed from detours and collisions in the history of ideas. His works claim skill, beauty and wonder: coloured glass vessels curvaceously hold their ground, mirrors infinitely repeat design objects, reflections distort to make the abstract more abstract, chandeliers glisten at ground level. Training at Rhode Island School of Design, and then studying as an apprentice to master glass blowers in Italy and Sweden, McElheny destroys assumptions of perception in a ludic dialogue mindful of the reverberations of the past on and in the present. Light, reflection and the production of culture are at the heart of this artistic practice running on a double production track of knowledge and sensorial experience, informed by the distribution, accumulation and rumours that produce each fragile version of the present.

In 1976, Werner Herzog made one of his strangest films, *Heart of Glass*. Based on Bavarian folklore and set in an eighteenth century pre-industrial past, it is a study of the power and desire associated with aesthetic beauty – in this case, found in a reflecting red glass renowned for its delicacy and beauty. This 'ruby glass' is manufactured in a glass factory located in a remote rural village. The unexpected death of the factory foreman precipitates the economical and psychological breakdown of the village as the knowledge of the glass recipe vanishes with him. The factory owner searches in vain to find a way to produce

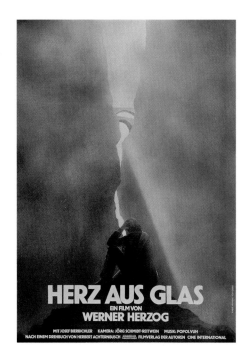

Werner Herzog
Poster for *Heart of Glass*, 1976

left:
Josiah McElheny
Screen For Observing Abstractions
No. 5 and *No. 3*, 2011
Installation view:
The Past Was A Mirage I'd Left Far Behind, 2011-12

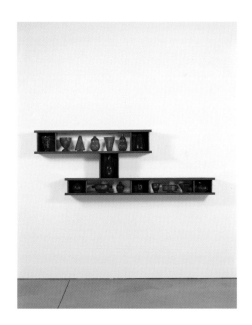

Josiah McElheny
Charlotte Perriand (and Carlo Scarpa), Red, 2009
Handblown glass, wood, metal, and polished
lacquer paint
79.4 × 228.6 × 33 cm

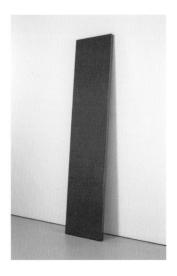

John McCracken
XIN, 1987
Polyester resin, fibreglass and plywood
243.8 × 53.7 × 5.4 cm

the glass – a task that becomes the 'master's malady' as he descends into a madness infecting the whole village. The oddness of Herzog's film lies in the acting style: save for an actor playing a cowherd-visionary and glass workers using high temperature furnaces, all of the cast deliver their parts under hypnosis. In one scene, the master's servant caresses a display of ruby glass vessels while speaking a monologue describing a town made of coloured glass as, trance-like, her hands move between the forms. She tells of streets and buildings, occupied by people and animals. The words were not scripted, rather improvised by hypnotic suggestion. Herzog used hypnosis to achieve a very particular acting style formed of 'fluid, almost floating movements, which meant that the film would seem to depart from known behaviour and the gestures would have an atmosphere of hallucination, prophesy and collective delirium at the end.'[1]

Heart of Glass is concerned with the resonance of rumour, style, truth and failure, employing the reflective and light-catching properties of glass as an analogy for the distorting processes of narrative. His ruby glass is a deep red colour, as seductive as the materials McElheny uses in *Charlotte Perriand (and Carlo Scarpa), Red* (2009), a sculpture formed from three rows of red handblown – by McElheny himself – glass replicas of 1950s designs by the architect and exhibition designer Scarpa. The glass objects are sitting on shelves that are historic variations of the famous 1953 bookcase Le Mexique, designed by Charlotte Perriand. The shelves are as polished as a John McCracken 'plank' – hand-formed sculptures he began making in 1965 condensing process into form. McCracken used excessively sensual colour 'structurally' rather than 'decoratively',[2] his highly reflective surfaces pulling everything surrounding them into their own structure. The unfeasible perfection of both McCracken and McElheny's sculptures are only possible through the work of the hand – indeed, maybe these finishes are so impractically faultless that the objects actually become vulgar, too faultless to be tasteful. Writing on Donald Judd's sculptures, which too often are erroneously attributed to indifferent machine-crafting, McElheny has pointed to the fact that:

> An incredible amount of labour and care was taken to create Judd's works,
> from handling materials as they came into the shop, to assembly, polishing and
> shipping. If his works had truly been machine-made in an assembly line, they
> would actually be much more rustic, cheap, or tricky in how they would have
> had to hide the problems and flaws in production itself.[3]

The inherent fiction of capitalism is that the machine can replicate the hand; the story of modernism is tainted with the replication of the machine aesthetic by the hand to achieve an industrial perfection.

To blow glass is to press one's breath into a form that turns from liquid to solid, to then reflect and capture light. Glass is a material modernist architects and designers projected the future through in a celebration of its ability to draw light into space when transparent and, when opaque, to reflect with no shadow. It is also a material entrenched in museum conventions of display, a rich seam of research for McElheny. *Endlessly Repeating Twentieth Century Modernism* (2007), for example, is a large cube that sits centrally in the gallery, seemingly just floating off the floor. Made of dark metallic surfaces, it reflects the spaces that hold it; two-way reflective windows affording a view of the displays of glass vessels cut into the upper part of the cube. Whoever enters the room is reflected in the surfaces of the cube, but as one moves to inspect the contents of the bays, the only reflections that can be seen are an endless parade of iconic design objects of the twentieth century – it is only the long view that makes individual subjectivity visible. Such is the failing of the museum of material culture.

Light and reflection have become set in history as emblems of modernity, imbued by the visionary architects, poets, and writers of the first decades of the twentieth century, such as Bruno Taut, Paul Scheerbart, Adolf Loos and Buckminster Fuller, as capable of reconfiguring perceptions and ushering in preferable futures. These figures – who all slipped outside of the canonic mainstream, thought architecture capable of shifting perception; a process that, in turn, might change the world for the better. McElheny notes: 'Reflective objects cannot operate independently of conscious perception. I am interested in the idea that the materiality of reflectivity itself contains a variety of ideas, concepts and conundrums'.[4] In 2003, the sculpture *Buckminster Fuller's Proposal to Isamu Noguchi for the New Abstraction of Total Reflection* made material an idea developed between the architect and sculptor in a conversation reported to have taken place in 1929 in a Greenwich Village pub, named Romany Marie's. As is often the case, McElheny took a little-known event in the history of ideas, grabbing something from the past and throwing it into the present to make understanding awkward. Fuller, the visionary architect and Noguchi, the artist, an assistant to Brancusi who worked on the Parisian sculptor's high-shine surfaces, discussed the possibilities of an invisible sculpture where reflective forms would be presented in a totally reflective environment. McElheny's sculpture is a realisation of this notion, some 74 years after the conversation.

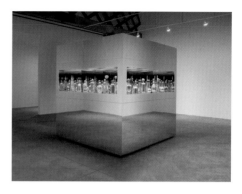

Josiah McElheny
Endlessly Repeating Twentieth Century Modernism, 2007
Handblown mirrored glass, low-iron and transparent mirror, metal, wood, electric lighting
240 × 235.6 × 235.6 cm
Collection Museum of Fine Arts, Boston
Museum purchase with funds donated by the Linde Family Foundation

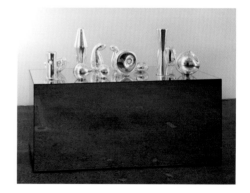

Josiah McElheny
Buckminster Fuller's Proposal to Isamu Noguchi for the New Abstraction of Total Reflection, 2003
Mirror and glass
Overall: 132 × 182.9 × 87.6 cm

A machine-made mirrored glass plinth supports a range of mirrored handblown glass objects, reflecting both themselves and their echo through light, not shadow. The sculpture represents 'live and direct': it is a tautological object that holds and produces time, repeating what exists like a real-time camera feed, filling the visual field with distortions.

An artist's task is to add objects and ideas into the world that extend and confound what is thought to be known, repurposing assumptions, colliding systems of understanding and proposing models of perception that extend thought. Accumulation of knowledge is an endless and immeasurable process. What use is art in addressing systems of accumulating knowledge? Can artwork contribute to such collections of facts without dipping into a nostalgic time travel or a recidivist archival love affair? How can the present be productively captured to engage with both past failures of the new and endemic infections of time? These are the questions that an art of the present must address to be necessary and relevant. McElheny employs a new configuration of artistic labour counter to the factory expertise or casual gesture that is the dominant form of contemporary production, approaching such imperatives through an interrogation of the experience of knowledge rooted in a constant curiosity. His sculptures seek out moments in history that the conditions of the present bring back into focus while considering the implications of Modernism and the ways in which the history of art and design carry content across time through form.

> When I am choosing the subject matter, it's often the subject matter that finds me. It's an instinctual process – not random, but still a chance-based occurrence. I often turn to footnotes or rare texts or historical objects, things that are considered distinctly unimportant or just not central to major historical narratives. The reason I do that – I think – is that these things seem more available to me; they seem more accessible to new thinking and new interpretations.[5]

His is an 'investigation of how material forms become infected with ideas that were used in its making',[6] a process that extends constantly from the time of production into the present.

Objects are inextricably related to the texts that attempt to represent them; any text on an artwork is a dangerous interjection that opens new routes for misinterpretation – museums are charged sites for the unreliable telling of history. These complexities are the matter of McElheny's work as he follows

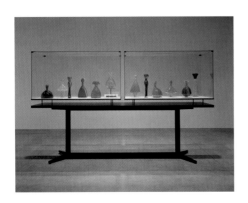

Josiah McElheny
From an Historical Anecdote about Fashion, 2000
Blown glass objects, display case, five framed digital prints
Dimensions variable

fragments of history that are half imagined, half probable. *From an Historical Anecdote about Fashion* (2000) began from a museum label for a mid-twentieth century vase that claimed workers in a glass-blowing factory were inspired to make the form, perhaps with a shadow of spite, by the shape of the factory owner's dresses. This not entirely accurate fact that McElheny himself openly misrepresents, took the artist's research to *Vogue*, postwar optimism and the entry of fashion into culture in order to explore how it is 'completely unpredictable how ideas move through culture and end up being expressed.'[7] McElheny's sculpture consists of text and photographs next to a pair of museum showcases attached to a table-height freestanding display structure, each vitrine holding six vessels made of handblown glass in various shades of green, yellow, brown and blue, shaped to Dior's distinctive 1947 'New Look' curves, a style characterised by ballooning skirts with small waists at the centre. Made from extravagant swaths of fabric, in defiance of postwar austerity, the shape became perversely emblematic of the 'look' of the era.

For the mobilisation of history to be productive, it must expand the universe of the past and open a light on the future. The question 'how do we recognise the present?' haunts McElheny's works, literally and metaphorically. In 1962, the American art historian George Kubler published a short book, *The Shape of Time: Remarks on the History of Things*, which came to resonate with a generation of artists and scholars rethinking ideas of the object. The conditions of our particular present have intuitively invested the text with a renewed currency nearly 50 years later, as it becomes referenced again by artists wrestling with the possibilities of sculpture. Kubler proposed a break with existing understandings of art history, suggesting that form and style should be turned away from as a categorising structure and that, instead, art should be considered a progressive continuous sequence of mutating, repeating and invented ideas *of* and *in* the world. Kubler used science as an analogy for his argument, describing that:

> Knowing the past is as astonishing a performance as knowing the stars. Astronomers look only at old light. There is no other light for them to look at. This old light of dead or distant stars was emitted a long time ago and it reaches us only in the present. Many historical events, like astronomical bodies, also occur long before they appear, such as secret treaties; aide-memoires, or important works of art made for ruling personages. The physical substance of these documents often reaches qualified observers only centuries or millennia

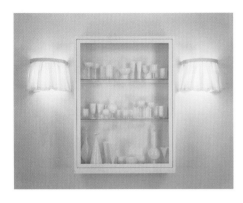

Josiah McElheny
Ornament and Crime, 2002
Handblown glass, sheet glass, wood, metal,
electric lighting, and fabric
129.5 × 213.4 × 30.5 cm

after the event. Hence astronomers and historians have this is common: both are concerned with appearances noted in the present but occurring in the past. The analogies between the stars and works of art can be profitably pursued.[8]

McElheny is drawn to objects that are of their own time, not those that might be claimed to be universal, timeless or malleable enough to navigate their way into a perpetual present. Such forms reveal through their flaws the conditions that brought them into being once transported into their futures; in their own time they caught the moment on the top note, only to quickly fall down with the weight of history and the impatience of recuperating style.

Two years after *The Shape of Time* was published, two events collided that, until McElheny's observations and extrapolations, had little congruence. In 1965, the Metropolitan Opera House in the Lincoln Center, New York, was in the midst of construction. The auditorium was to be lit by spiky-futuristic crystal chandeliers made by the Viennese master glassmaking company J & L Lobmeyr, one of the first companies to work with the modernist architect and designer Adolf Loos. In the architect's inflammatory 1908 essay 'Ornament and Crime', Loos damned the decadent decorative style of Art Nouveau as superfluous and immoral, unlike the purity of plain formality. McElheny used the title of this treatise in a 2002 sculpture, *Ornament and Crime*. This three shelved double-window wall-hung museum display case is filled with handblown white glass vessels, brightly illuminated from within. The whiteness eliminates all possibilities of a dogma-defying grey, somehow turning a design idea of purity into a disturbing ideological symbol. Like Loos, the German writer and draughtsman Paul Scheerbart and the architect Bruno Taut had a shared faith in architecture, believing it capable of solving some of the problems of humankind. Scheerbart's futuristic novels, such as *The Gray Cloth* and *The Light Club of Batavia*, and his manifesto *Glass Architecture*, dedicated to Taut, championed glass, colour and light as means to create an earthly paradise. McElheny's *The Alpine Cathedral and the City Crown* (2007–08) pairs these figures in two handcrafted crystalline architectural models that sit on a shared table-like display, illuminated from above and below by theatrical lighting excessive for the task, both – like Taut and Scheerbart's ideas – impossible models for a built environment.

The 1965 Lobmeyr chandeliers were reimagined in light of 'current events' and finally were dramatically unveiled the following year, hanging from the high ceiling of the Opera House like galactic clusters – best seen from the cheap seats – retracting heavenwards as the curtain rises. The same year, empirical

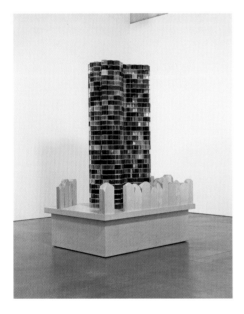

Josiah McElheny
*Bruno Taut Monument to Socialist Spirituality
(After Mies van der Rohe)*, 2009
Handblown and moulded glass modules, wood,
hardware
286.6 × 190.5 × 139.7 cm

evidence supporting the theory of the Big Bang was first published, the chosen title for this astronomical event capturing a public, non-specialist, imagination with the proof that all the stars and galaxies of the universe are in motion breaking with the notion of a static universe with humankind at its centre. In 2005, McElheny brought these 40-year-old events together in *An End to Modernity*, an expressive diagram of the Big Bang, developed in collaboration with the cosmologist David Weinberg, formed of a nearly five-metre diameter sculpture modelled on the Lobmeyr design. The scientist describes how 'the Big Bang is not an explosion of material into space; it is the origin of space and time, initiating an expansion that has no centre';[9] a singular activity originating at a particular time and place that initiated an infinite expansion of the universe passing through the past, present and future. Just like the fate of modernism, the Big Bang is a scattering that continues to unfold.

As is usually the case with his sculptures, slithers of information that are rigorously researched by talking to specialists were McElheny's starting points for *An End to Modernity* (2005). As well as working with Weinberg for more than five years on the diagram and its various sequels, the artist researched in detail the history of the chandeliers. Lobmeyr's designs are not rarefied; they simply responded to the client's wishes that they looked like popular representations of galaxies. The results are brash explosions of crystal, styled from an idea of eighteenth century ornamentation, coterminous with the products of Herzog's fictional glass blowing factory. Made from over one thousand handblown glass segments and more than five thousand aluminium parts, McElheny's futuristic cosmological reworking of the form seemingly explodes out from the centre, with his reinvention bringing the chandelier from its suspended position down to the floor. *An End to Modernity* hangs some 15 centimetres above the ground enabling it to be wondered at and observed as it mutates from a populist space-age approximation to an accurately modelled scientific diagram. Metal rods representing the specific lengths of time in this schematic radiate from the centre ending on either a light bulb, which stands in for a quasar, or a cluster of glass discs and spheres, representing galaxies. Like a disco-ball representation of the break with a modernist unified vision or a 'Pop image of the Big Bang'[10], *An End to Modernity* is compellingly vulgar, disturbingly beautiful, and as confusing as the experience of one's own present.

McElheny's work with Weinberg continued in the sculptural installation *Island Universe* (2005–08), a work first installed in Madrid's reflecting glass Palacio de Cristal, a building modelled on the earlier London Crystal Palace (1887).

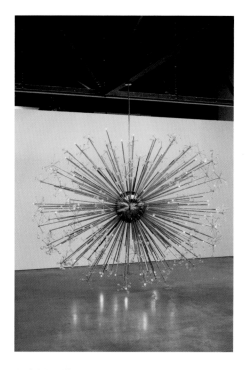

Josiah McElheny
An End to Modernity, 2005
Chrome-plated aluminium, electric lighting, handblown glass, steel cable and rigging
488 cm diameter

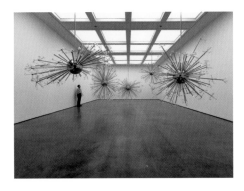

Josiah McElheny
Island Universe, 2008
Chromed aluminium, handblown glass, electric
lights. Consisting of five elements arranged in
a grid at specific heights
Dimensions variable
Installation view: *Josiah McElheny: Island
Universe*, White Cube, London 2008

Here, five sculptural elements hung from the ceiling in an explosion of highly reflective chrome-plated aluminium rods, each cluster representing one model of five possible universes at specific moments in time. To experience either *The End of Modernity* or *Island Universe* is to be thrown off balance, as the suspended objects reflect and distort all that surrounds them, changing constantly as one moves around to try and make sense of form's position in space – the fundamental question of sculpture. This involvement of the beholder in the work extends to *The Past Was A Mirage I'd Left Far Behind*, McElheny's 2011 Bloomberg Commission at the Whitechapel Gallery. The installation consists of seven sculptures made from mirrors, cloth and projections of abstract films. These hold time and all that surround them in an endless deferral of their own identity: to look at the mirrored works is to be instantly implicated, doubled and redoubled across the field of vision, promoting responses that are self-conscious. The films that repeat and reflect infinitely in the mirrors are culled from the history of the moving image, and transferred from their original format to reconfigured digital versions, selected not by the artist, but rather, in a double deferral, by selectors invited by the exhibiting venue. To experience this work is to experience a real-time misrepresentation oscillating through the present. These are demonstrations, not illustrations, of the failure of history; a pitting of the abstract against the ornamental to slice thorough expectations of perception. Importantly for McElheny, this reflects '... my belief that ideas perceived as fundamental in art, politics – any realm really – are often the result of misinterpretations, mistakes or speculation'.[11]

In these, and other works, McElheny is concerned with the social circumstances that informed the development of Modernism, observed from a position that is only possible with historical distance. Modernism was a time when belief in progress proclaimed a new way of both understanding and occupying the world, while today such experiments endure as 'style' – a look, rather than a belief in radical change. An exhaustion of a set of possibilities does not draw a dialogue to a close; rather it opens up a new set of possibilities that are driven by a revaluation and renewal of what has been given before. In this way an art of the present becomes possible.

1 Paul Cronin (ed.), *Herzog on Herzog*, (London: Faber & Faber, 2002) 126.

2 Neville Wakefield (ed.), *John McCracken, Sketchbook*, (Sante Fe: Radius Books, 2008) 55 in original sketchbook.

3 Josiah McElheny, 'Invisible Hand' in *Artforum*, (Summer 2009) 209.

4 Louise Neri and Josiah McElheny, 'An End to Modernity' in *Josiah McElheny: A Prism*, Louise Neri and Josiah McElheny (eds.), (New York: Skira Rizzoli, 2010) 164.

5 Josiah McElheny, in 'Matthew Buckingham by Josiah McElheny', *BOMB 107*, (Spring 2009) 92.

6 Josiah McElheny, in 'Arturo Herrera by Josiah McElheny', *BOMB 93*, (Fall 2005) 7.

7 'A Conversation about Overlapping Cultural Histories of Production in Art, Design and Fashion' in *Parkett* No. 86., 2009, 119.

8 George Kubler, *The Shape of Time: Remarks on the History of Things*, (New Haven: Yale University Press, 1962) 17 (original emphasis).

9 David H. Weinberg, 'From the Big Bang to the Multiverse: Translations in Space and Time' in *Josiah McElheny: A Prism*, Louise Neri and Josiah McElheny (eds.), (New York: Skira Rizzoli, 2010) 68.

10 Josiah McElheny, *For an Island Universe*, (Madrid: Museo Nacional de Arte Reina Sofia, 2009) 23.

11 *Ibid., 26.*

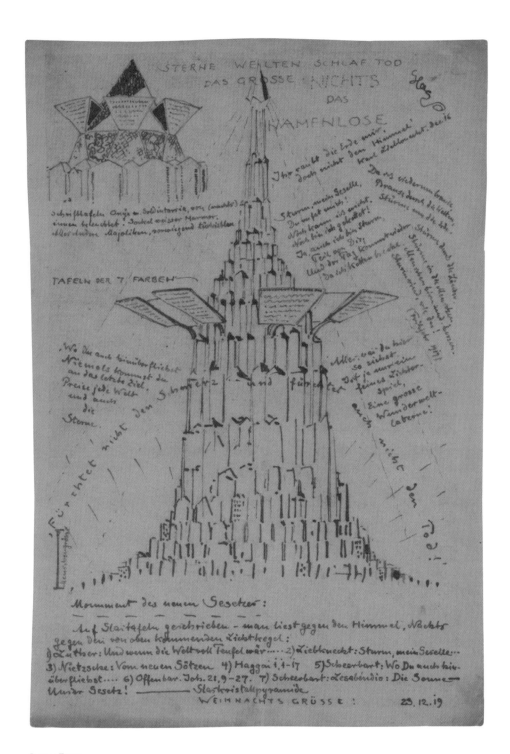

Bruno Taut
Letter to the Crystal Chain, 23rd December 1919
Crystal Chain Collection 118-12-71, Academy of
Arts, Berlin

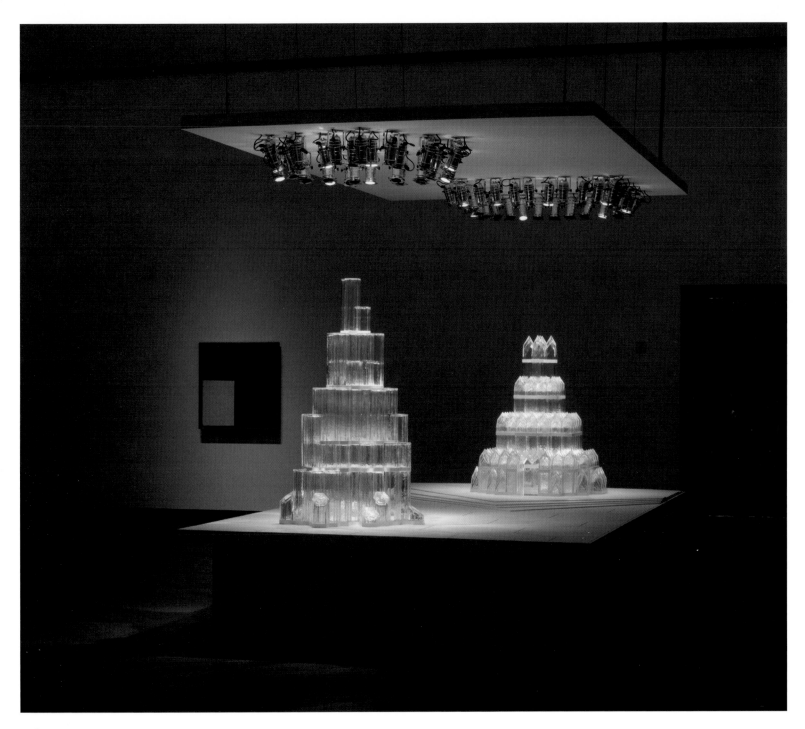

Josiah McElheny
The Alpine Cathedral and the City-Crown, 2007–08
Handblown glass, metal, painted wood, acrylic,
electric lighting
427 × 245 × 22.5 cm
Commissioned by the Museum of Modern Art, New York
Installation view: *The 1st at Moderna: Josiah McElheny,*
The Alpine Cathedral and the City-Crown, 2007–08

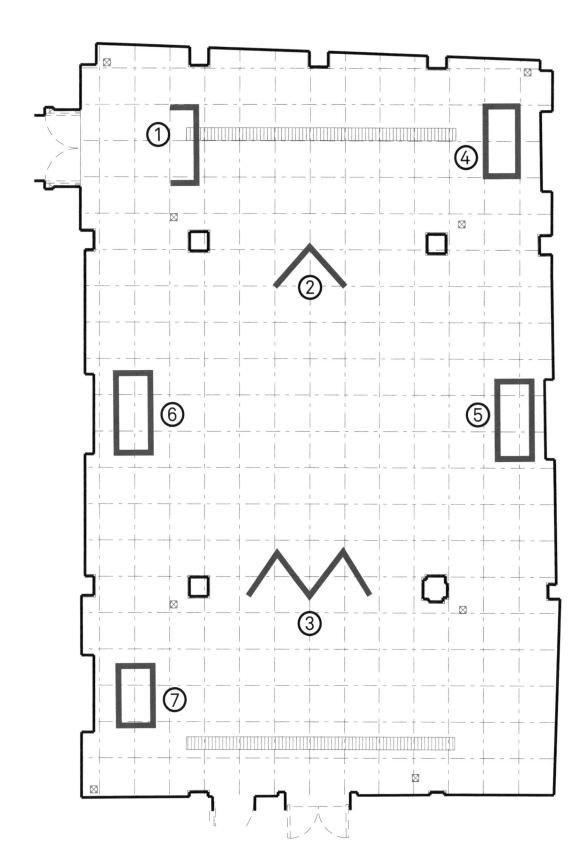

Floorplan:
The Past Was A Mirage I'd Left Far Behind, 2011-12
The Bloomberg Commission
Whitechapel Gallery, London

Daniel F. Herrmann

The Past Was A Mirage
I'd Left Far Behind

In his poem *Whitechapel Library, Aldgate East*,[1] Bernard Kops describes the
library as a place of refuge and revolution. Using popular rhyme and verse, the
London poet's alter ego speaks of crowded living conditions, economic hardship
and the self-perpetuating acceptance of one's own standing. A cacophony of
voices argue for conformity:

> Be like your brothers, what else is life for?
> You're lost and you're drifting, settle down, get a job. [...]
> Come back down to earth, there is nothing more.

The alternative to the proposed complacency lies in the Whitechapel Library,
a place in which – as the poet describes it – 'my brain explodes when I suddenly
find, an orchard within for the heart and the mind', and where his 'thoughts
were to rage'. The library experience is conjured up in vivid terms; the damp
London weather is just as much part of it as the body odour of fellow library
users. Reading and learning are not described in terms of Apollonian restraint,
but as Dionysian activities of near-gluttonous joy:

And I am a locust and I'm at a feast.
Whitechapel Library, Aldgate East.
And Rosenberg also came to get out of the cold
To write poems of fire, but he never grew old. [...]
I ate book after book, page after page.
I scoffed poetry for breakfast and novels for tea.
And plays for my supper. No more poverty.

Here, the forceful and hedonistic aspect of the protagonist's literary consumption expresses its political impetus, namely, financial and intellectual poverty is one determined by material conditions and social conventions. The poem claims these to be a 'mirage' of the past, which can be overcome by means of edification. It is an optimistic, perhaps romantic, but certainly modern attitude towards the revolutionary potential of art.

Borrowing a line from Kops' poem for its title, the most recent large-scale installation by US artist Josiah McElheny shares an affinity and enthusiasm for an attitude towards art, culture and education as means of self-realisation and class-transcendence. At the same time, it approaches them with an acute awareness of the dogmatic failures of the Modernist project. His installation for the Whitechapel Gallery, *The Past Was A Mirage I'd Left Far Behind*, proposes a reassessment of utopian promise through physical and sensory experience. It does so by employing the history of its location and an awareness of its formal predecessors.

The Bloomberg Commission is the Whitechapel Gallery's annual commissions programme. It is designed to display the work of a single artist for one year in a dedicated exhibition space. This room is the former reading room of the Passmore Edwards public library, which has been part of the extended Whitechapel Gallery since 2009. Architecturally, its roughly 280 square metres are defined by exposed yellow bricks that were manufactured in the late nineteenth century in nearby Brick Lane. Its columns and pilasters – not yet mass manufactured, and ornamented with geometric shapes – speak of its 1892 construction, while four generous skylights display the traces of recent architectural developments. With warm brickwork and period features, this room can be seen in contrast to post-1945 white cube gallery spaces.[2] At the same time, its windowless walls and the emphasis on natural light from the ceiling locate the room firmly in a lineage of twentieth-century public exhibition buildings. With more than 100 years of use by the East End's diverse communities, including local families, migrants and

intellectuals, the history of its location is ingrained and inscribed into the very fabric of the space. For many years, it was informally known as the 'university of the ghetto'[3] – a place of education and community organising. This is the context within which McElheny began to conceive of his commission project:

> [...] There was also this historical fact that the library had been considered 'a lantern for learning', [...] a building built to project light out into the neighbourhood. I thought about how to reverse that and have this light projected and refracted within the space, thinking about abstraction as an ideal of an enlightenment, of a new understanding of the world. This is a discredited notion and I was interested in how we could come back to that and find a way forward through the idea of abstraction itself.[4]

Using the history of the exhibition space as the background for his commission, the artist decided to engage with a fragmented approach to the past, abstraction and sculptural form. He has created a series of mirrored sculptural screens onto which are projected reconfigured abstract films selected by external collaborators, thus creating a subjective and non-canonical study of abstraction in film.

When entering the Whitechapel Gallery through what used to be the main entrance of the library building, a visitor will notice McElheny's installation before even crossing the threshold. The doors to the exhibition are in the primary sightline of one of the two street-level entrances to the gallery. Even in bright sunshine, passersby can perceive the symmetric motion of images and light. Upon entering the gallery and walking towards the exhibition, the visual sensation multiplies and unfolds, as well as being complemented by sound: images move in unison, visible from every position in space, projected at and projecting in unexpected angles, in changing configurations and unpredictable rhythms. Patterns emerge and refract; colours reflect throughout the room, create pools on the polished floor and are absorbed by the muted brickwork. One makes out human forms: one's own image and that of fellow visitors. These are perceived not only once, but several times, and sometimes in multiple places simultaneously, reflected in an intricate stage set of sculptural screens made of mirror and projection material, suspended in space by vertical wooden beams. The projected and moving images change constantly, altering the intensity of light throughout the room and allowing for varying sightlines, vistas and reflective connections to be explored.

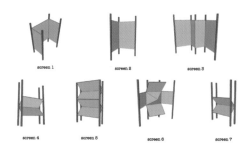

Computer Assisted Design for *Screens For Observing Abstractions, Nos 1-7*, 2011

Josiah McElheny
Screen For Observing Abstractions No. 4, 2011

The room is host to seven different sculptural screens, each entitled *Screen For Observing Abstractions*, followed by a number from '1' to '7'. On entering, the first of these pieces (*Screen For Observing Abstractions No. 3*) seems to resemble a larger-than-life, four-panel dressing screen. Its centre panels are highly reflective mirrors. Beside the mirrors are the screen's outer panels, made of white semi-translucent projection film. Two projectors throw a synchronised moving image onto each film panel, which is then reflected in the mirrors. But here, something unexpected starts to happen. Joining in the perfectly aligned mirrors, the reflections seem to create a three-dimensional space behind or within the realm of the mirror. Attempting to make sense of this optical conundrum, the beholder's eye collages the projections and their reflections into a new reality – an altered variation of whatever image was originally present.

This seemingly simple visual effect is present in the various iterations of the perpendicular mirror screens. Another sculpture (*Screen For Observing Abstractions No. 5*) resembles the first, but is rotated by 90 degrees: its mirrors zigzag towards the ceiling, and the single projection onto its centre creates a gently curving image space. Two other sculptures resemble a complementary, or perhaps antagonistic, pair (*Screen For Observing Abstractions No. 4* and *No. 7*). They consist of the same perpendicular element of mirror and projected film that one has already encountered, but in the former, the mirror is on top and the film panel on the bottom while in the latter the arrangement is turned on its head. It is a deceptively simple yet very effective operation. As the joint between the two panels recedes away from the viewer, the sculptures entice one to step forward and take a closer look. Almost immediately, this results in an interruption of the projection and one's shadow being cast then reflected and doubled onto the surface. The reflected silhouette becomes part of the reflected image. This incorporation of the viewer's mirror image into the reception of the work becomes particularly clear in the sculpture that contains two mirrors in perfect parallel (*Screen For Observing Abstractions No. 1*). Moving towards the screen and stepping between its mirrors, the visitor finds his or her image multiplied *ad infinitum* along with an endlessly stretching projection, and the reflection bouncing back and forth between the two looking glasses. One then attempts to catch one's own eye in the mirror, but while this is possible with the first reflection, all further views are so exactly aligned behind it that it is impossible to do so again. Here, the infinite narcissistic extension of the self becomes a commentary on the limits of observation.

While all seven sculptures in the space operate on the basis of doubling

and/or rotating the basic perpendicular module (*Screen For Observing Abstractions No. 2*), only one synthesises both these elements. The centre of *Screen For Observing Abstractions No. 6* resembles a rectangular, mirrored pyramid whose apex points towards the viewer. From its wall-facing base extend four projection panels, not unlike petals, on all sides. A single projector throws its image onto the tip of the central pyramid, and the surrounding panels receive it and create reflections that align in geometric beauty into a crystal-shaped composite of complementary image fragments.

While McElheny's installation has a strong visual impact, the sculptures emphasise spatial and temporal perception, as any movement in the exhibition space results in different configurations of the reflections. Walking towards the images, the visitor comes to interrupt the projection, and his or her own shadow multiplies and extends. Thus, the beholder becomes part of the reconfigured images produced by the artwork. In contrast to the traditional planar consumption of cinematic projections, McElheny's crystalline iterations offer a fragmented and multifaceted viewing situation, making for an immersive experience that is dependent on the viewer's own position in space. This particular viewing environment is what differentiates the artist's installation from the work of artists who could be seen as his formal predecessors. Mirrored sculptures have a rich history in twentieth century art,[5] with such well-known examples as the Arte Povera sculptures of Michelangelo Pistoletto or the reflective surfaces of Gerhard Richter's stacks of glass. But whereas these examples utilise the mirror to explore the category of figuration in relation to painting, McElheny's work is more concerned with the conceptual arrangements of Robert Smithson or Dan Graham.

Smithson's *Enantiomorphic Chambers* (1965), now destroyed, consisted of two steel and mirror structures, designed to deflect and guide one's view. The wall-mounted polychrome sculptures with blue steel framework and green-tinted mirrors presented an unfamiliar set up of mirror-vision. Instead of delivering the expected experience of reflective glass, Smithson's sculptures diverted the viewer's gaze from their own central focal plane to their sides, effectively presenting 'a blind spot at the centre of vision.'[6] This defamiliarising set-up allowed visitors to question the very conditions of their own perception: 'one has to think about sight to comprehend a situation in which one sees nothing'.[7] The parallels with the installation *The Past Was A Mirage I'd Left Far Behind* can be seen in the way in which McElheny employs mirrors to extend vision, defamiliarise viewing situations and deliberately allow for alternate viewing

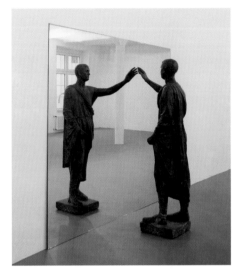

Michelangelo Pistoletto
L'etrusco (The Etruscan), 1976
Mirror and plaster reproduction of a classic sculpture
Statue: 194 × 90 × 80 cm, mirror: 220 × 280 cm
Goetz Collection, Munich

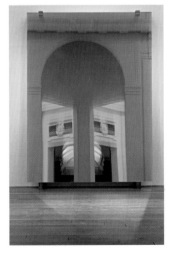

Gerhard Richter
11 Panes, 2004
Glass
290 × 212 × 54 cm
ARTIST ROOMS, National Galleries of Scotland and Tate.
Acquired jointly through the d'Offay Donation with assistance from the National Heritage Memorial Fund and the Art Fund 2008

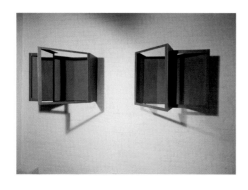

Robert Smithson
Enantiomorphic Chambers, 1965
Steel and mirror
60.9 × 76.2 × 78.7 cm

experiences. Furthermore, both his and Smithson's sculptures use mirrors to affect binocular vision whereby the viewer perceives an optical illusion of three-dimensional depth when standing in a particular position towards the angled mirrors. But whereas Smithson set up an optical experiment for isolated perception by an individual viewer, McElheny's sculptural arrangements highlight the reflective connections between the seven structures and, by extension, the different viewers within the exhibition space.

This emphasis on the role of the spectator in McElheny's commission is reminiscent of the work of Dan Graham. Graham is renowned for his early incorporation of closed-circuit video cameras and the aesthetics of surveillance.[8] For his installation *Public Space/Two Audiences* (1976), Graham constructed a rectangular room with one mirrored wall at the far end. The space was bisected along its short axis by a sound-insulating pane of glass, effectively creating two separate rooms, each accessible through its own door. Inside, visitors found themselves in a situation of explicit observation. Separated by the glass wall, two groups of viewers were watching each other, as well as themselves. Individual gazes would not just be returned by those on the other side of the glass, they would also be reflected by the mirror, and the glass wall itself, thereby creating an intricate set of relations between the visitors. The accompanying explanatory material to the installation gave explicit instructions:

> Spectators can enter the work through either of two entrances. They are informed before entering that they must remain inside for 10 minutes with the doors closed. Each audience sees the other audience's visual behaviour, but is isolated from their aural behaviour. Each audience is made more aware of its own visual communications. It is assumed that after a time, each audience will develop a social cohesion and group identity.[9]

Graham's installation essentially constituted the set-up of a cognitive, as well as sociological, experiment. The audience was being divided into two groups: visitors in the room between the mirror and the glass wall were able to 'choose between several alternative ways of looking', whereas those in the room without a mirror 'tend to look collectively in one direction.'[10] The experiment equips its test subjects with different privileges. Herein lies the difference to Josiah McElheny's installation. For *The Past Was A Mirage I'd Left Far Behind*, the artist also conceives a viewing situation, at the centre of which lies the act of observation itself. In contrast to Graham's *Public Space/Two Audiences*,

however, the framework of reception is less confined. Viewers are not guided in terms of how long they are to spend in the installation. The terms of observation – duration, direction, and access to alternative ways of observation – are not explicitly stated, but more malleable and to a larger part determined by the participants: visitors can come and go, chose their own position towards the mirrored sculptures and their reflections, and change these as they please. In this way, McElheny's work follows not so much the model of the experiment, but much rather that of the spectacle, the publicly and communally observed visual delight.

By carefully arranging his sculptural screens and allowing for a visual experience of varying light conditions over time, McElheny places his installation in the historic vicinity of the popular light displays and colour pianos – mechanical devices using keyboards to manipulate lights – prevalent in cinemas and fairgrounds in many European cinemas before the Second World War. But he also references the interest of Modernist avant-garde artists in utilising these forms of entertainment for artistic purposes. *Light Prop for an Electric Stage (Light-Space Modulator)* (1922-30), developed by the groundbreaking Hungarian artist and Bauhaus teacher László Moholy-Nagy, has become the most famous of these. First displayed to a larger public at the Deutscher Werkbund exhibition in Paris in 1930, the device consisted of an arrangement of perforated metal plates and glass forms that were set in motion by an electric motor. Lit by assorted coloured lights, its purpose was the generation of continuously changing abstract light and shadow patterns. The study and analysis of colour phenomena was not only crucial to the foundation course of the Bauhaus art school, the use of moving images for artistic purposes was also a goal of Modernist aesthetics. In his widely read book *The New Vision* (1928),[11] Moholy-Nagy proposes the five 'stages of the development of sculpture', a progression that starts with 'blocked-out' sculpture and finds its contemporaneous zenith in 'kinetic sculpture'.[12] The artist declares the next stage for this evolutionary account of sculpture to be the use of light: 'Ever since the introduction of the means of producing intense artificial light, it has been one of the elemental factors in art creation, though it has not yet been elevated to its legitimate place.'[13] He goes on to develop a speculative taxonomy of light sculpture:

a) The film with its unexplored possibilities of projection, with colour, plasticity and simultaneous displays, either by means of an increased number of projectors concentrated on a single screen, or in the form of simultaneous

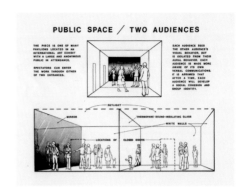

Dan Graham
Public Space / Two Audiences, Diagram, 1976

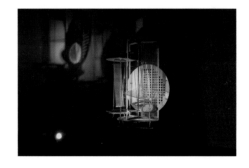

László Maholy-Nagy
Licht-Raum Modulator, 1922-30 (replica 1970)
Metal, wood, glass, motor
201.7 × 78.8 × 69.7 cm
Collection Van Abbemuseum, Eindhoven,
The Netherlands

image sequences covering all the walls of a room;

b) Reflected light displays of pattern sequences produced by colour organs; such displays may be open for many or limited to a few; they may be individual improvisations, of isolated nature or they may be multiplied by means of television;

c) The colour piano, whose keyboard is connected with a series of graduated lamp units, illuminates objects of special materials and combines the plan of pattern with colour [...]

The Past Was A Mirage I'd Left Far Behind relates to all three of these points. With their 'manipulation of moving, refracted light', McElheny's simultaneous projections onto mirrored sculptures create an immersive environment. These projections are a further link between Moholy-Nagy and McElheny's interest in the legacies of Modernism. In concluding his taxonomy, the Hungarian artist mentions the 'light fresco':

d) The light fresco that will animate vast architectural units, such as buildings, parts of buildings or single walls, by means of artificial light, focused and manipulated according to a definite plan. In all probability, a special place will be reserved in the dwellings of the future for the receiving sets of these light frescos, just as is today for the radio.[14]

Here, Moholy-Nagy contemplated the remote transmission of light information according to a predetermined programme. But who produces his light fresco? A human performer, interpreting a standardised notation? Or a computer, executing a piece of code, perhaps via punchcard or electronic file? In an historic moment in which technology promises aesthetic freedom, *The New Vision* remains silent as to the artistic agency behind the manipulation of artificial light according to a 'definite plan'. Taking up Moholy-Nagy's idea of light sculpture as painting with 'flowing, oscillating, prismatic light in lieu of pigments',[15] Josiah McElheny's *Screens For Observing Abstractions Nos 1-7* reflect such ambiguity of authorship. Instead of taking on the traditional role of the artist-creator and projecting his own films onto his own sculptures, McElheny establishes a set of rules to use and reconfigure extant visual material, essentially creating an algorithm for appropriation.

In the first instance, McElheny approaches external collaborators to suggest 'a personal history of abstraction in film, which will form the basis for a choreo-

graphy that will be projected onto the sculptures'.[16] These suggested films provide the sources for the second part of McElheny's 'definite plan' in which moving images are meant to be shown 'upside down, flipped and in reverse'.[17] Finally, this process of temporal and axial reconfiguration is projected onto the mirrored sculptures, where it is reflected, multiplied, refracted and fragmented. The projections become a collage, in themselves mirroring the doubling, folding and inverting nature of the sculptures.

The rearranged projections do not reflect a canonical cinematic history of any kind. Nor do they propose the artist's personal interpretation of a specific history. As the result of combining the choices of external collaborators with the predetermined and 'definite plan' of a reconfiguration, McElheny distils the history of abstraction in film down to 'focused and manipulated artificial light'.[18] There is no prescribed guideline of historic interpretation, but instead an invitation to the audience to indulge in and gorge on a visual banquet:

'Come to the feast.'
Whitechapel Library, Aldgate East.[19]

1 Bernard Kops, 'Whitechapel Library, Aldgate East' in *Grandchildren and Other Poems*, (London: Hearing Eye, 2000).
2 See Brian O'Doherty, *Inside the White Cube: The Ideology of the Gallery Space*, (Berkeley: University of California Press, 1999).
3 See Richard Tames, *East End Past*, (London: Historical Publications, 2004) 111.
4 Josiah McElheny in conversation with Daniel F. Herrmann in this book, 76.
5 For an in-depth discussion of the cultural history of the mirror and its use in the visual arts, see Slavko Kacunko, *Spiegel – Medium – Kunst*, (Munich: Wilhelm Fink, 2010).
6 Ann Reynolds, 'Enantiomorphic Models' in Eugenie Tsai (ed.), *Robert Smithson*, (Los Angeles: Museum of Contemporary Art, 2004) 113.
7 *Ibid.*
8 Surveillance has been a major theme in Graham's reception from the very beginning, see R. Meyer, 'Dan Graham: Past and Present', in *Art in America*, no. 63 (November 1975) 83; Donald Kuspit, 'Dan Graham: Prometheus Mediabound', in *Artforum*, no. 23 (May 1985,) 75-81. For an astute recent discussion including the reception of Graham's work in terms of play and staging, see Isabelle Lindermann, *Betrachterfallen. Die Strategie der Verunsicherung in der Zeitgenössischen Kunst*, MA Thesis, Philipps University, Marburg 2010.
9 Gloria Moure (ed.), *Dan Graham: Works and Collected Writings*, (Barcelona: Ediciones Poligrafia, 2009) 113.
10 *Ibid.*, p.112.
11 László Moholy-Nagy, *The New Vision*, (New York: Wittenborn & Co., 1946) 50.
12 *Ibid.*
13 *Ibid.*, 50–51.
14 *Ibid.*
15 *Ibid.*
16 Josiah McElheny to Kenneth Goldsmith in a letter dated 14 August 2011.
17 Josiah McElheny in conversation with Daniel F. Herrmann and Tamara Trodd, 13 September 2011, in this book, 75.
18 As note 11.
19 Bernard Kops, as note 1.

Installation images

Josiah McElheny
The Past Was A Mirage I'd Left Far Behind, 2011-12

The Bloomberg Commission
Whitechapel Gallery, London

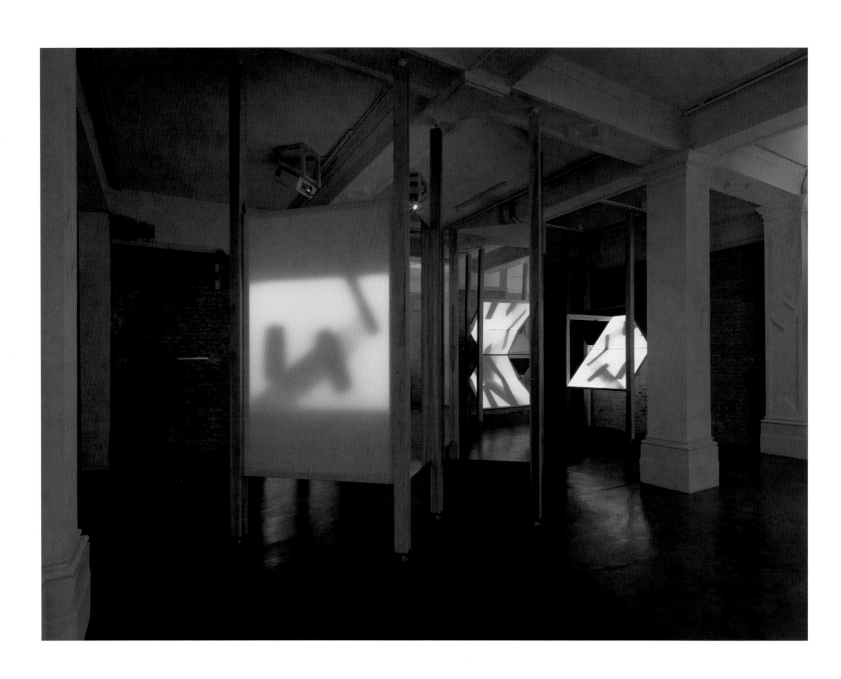

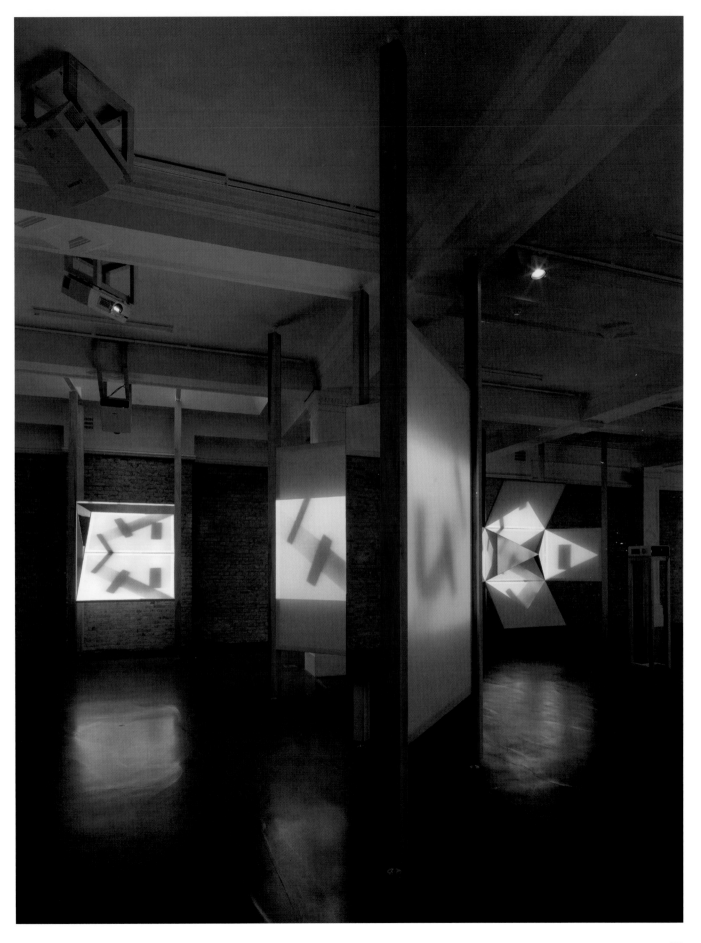

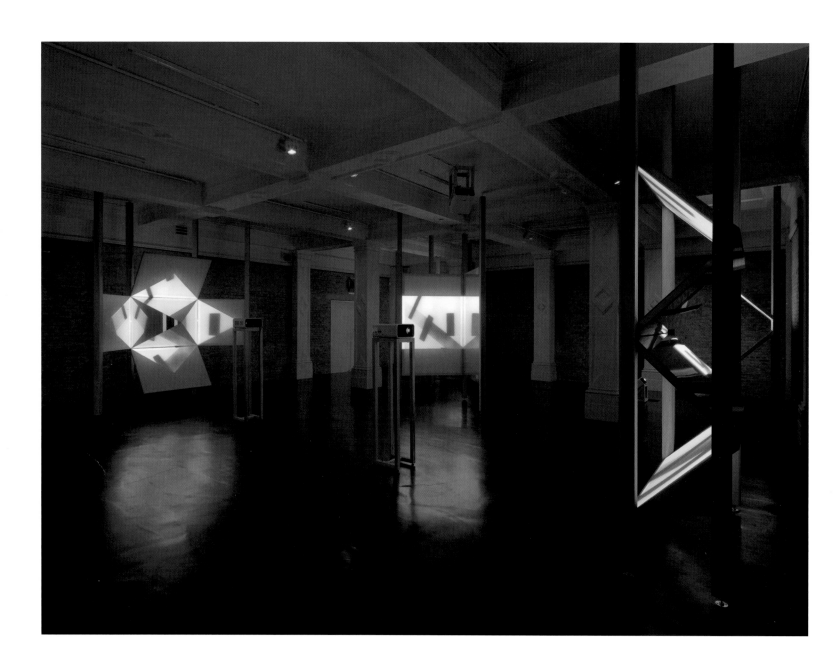

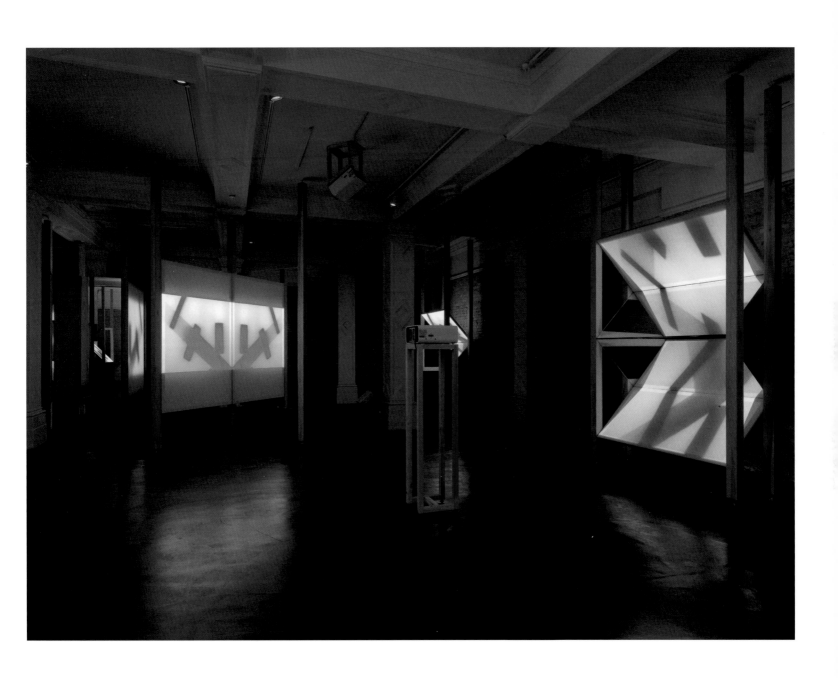

Screen For Observing Abstractions No.1
Wood, mirror, screen material and projection
Three-panel screen construction
Dimensions variable

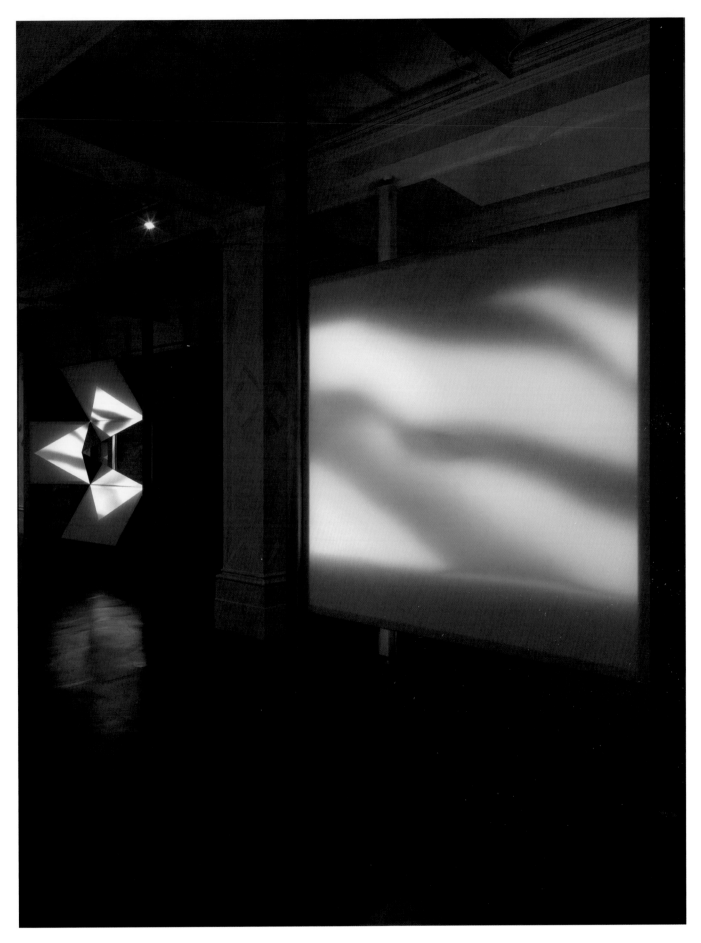

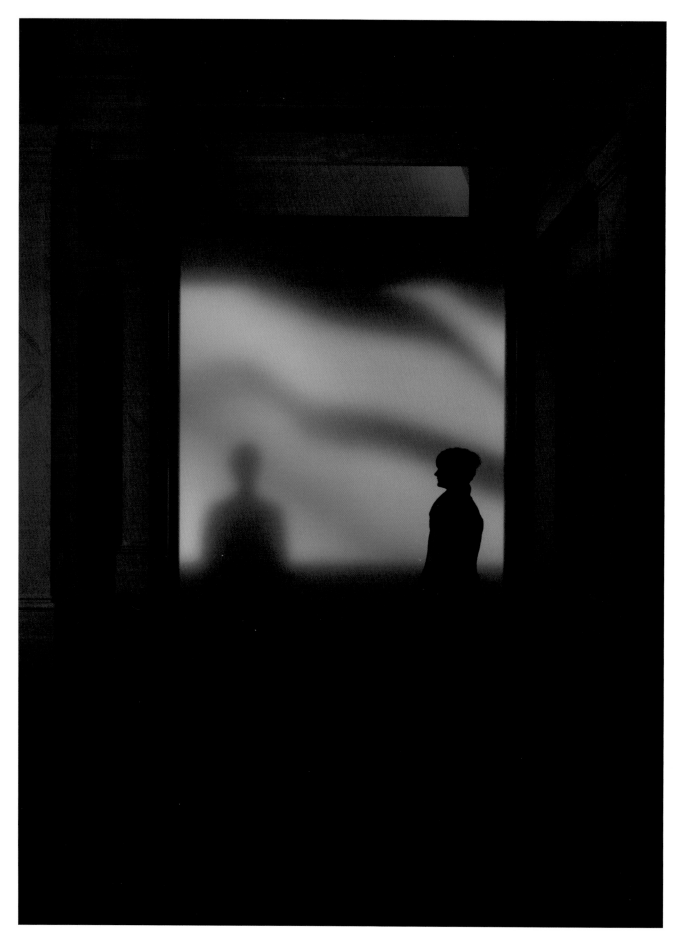

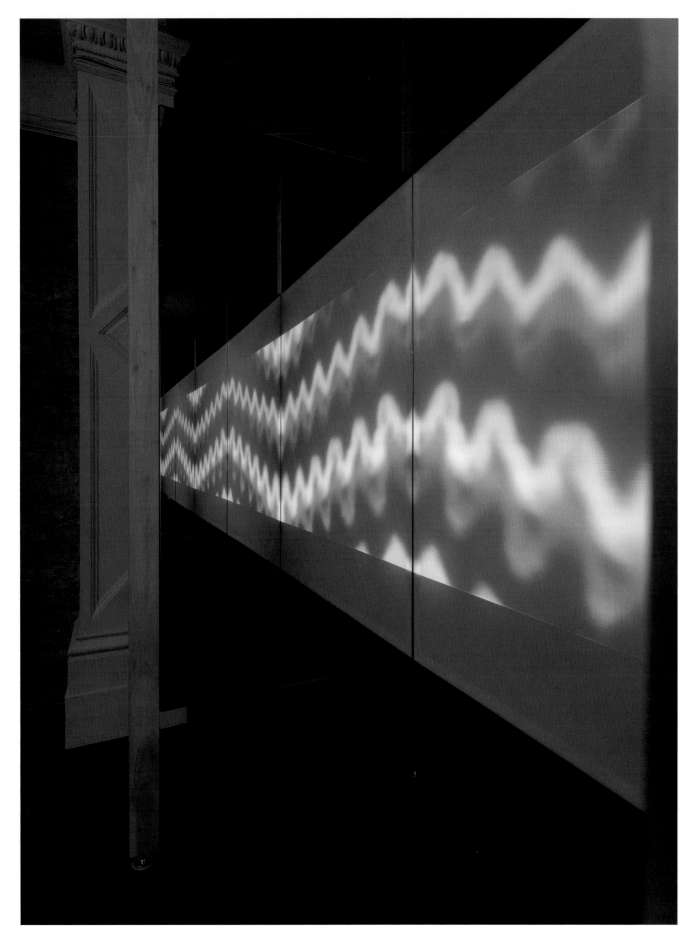

Screen For Observing Abstractions No.2
Wood, mirror, screen material and projection
Two-panel screen construction
Dimensions variable

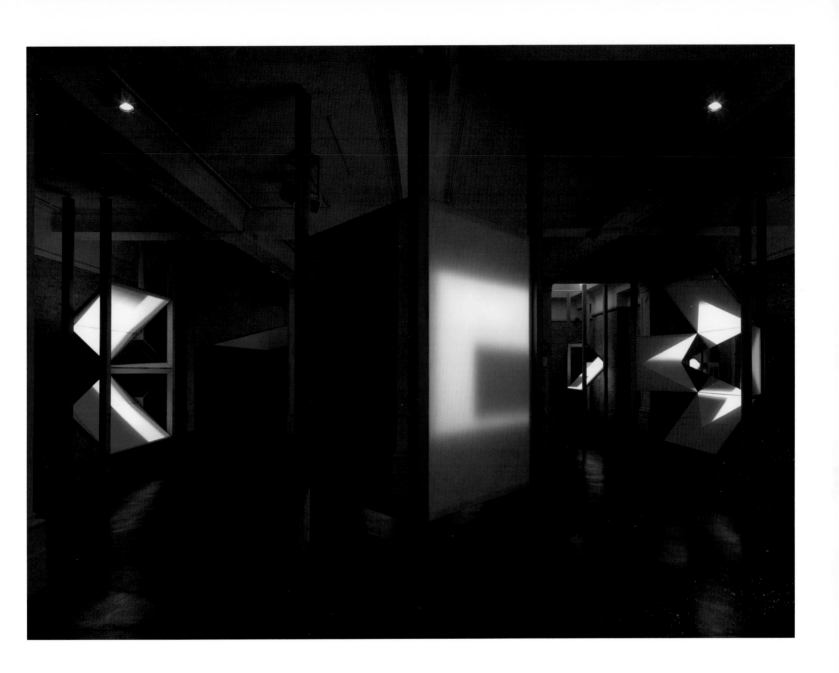

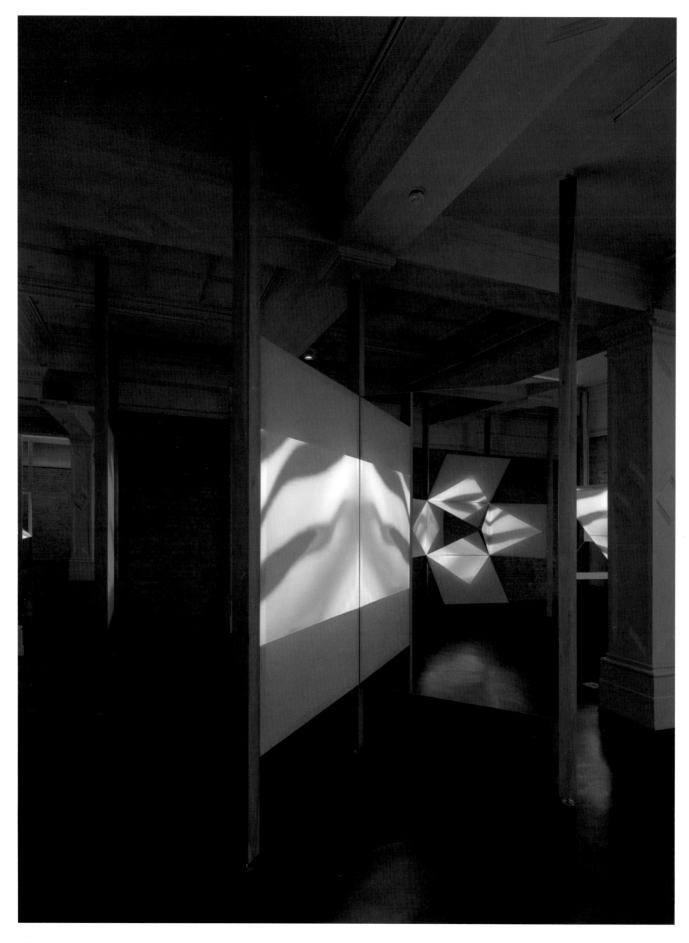

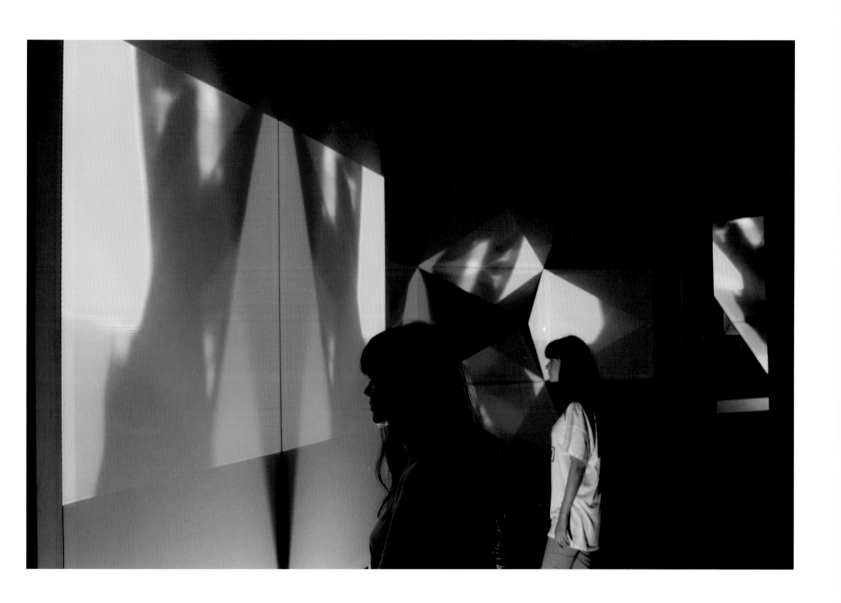

Screen For Observing Abstractions No.3
Wood, mirror, screen material and projection
Four-panel screen construction
Dimensions variable

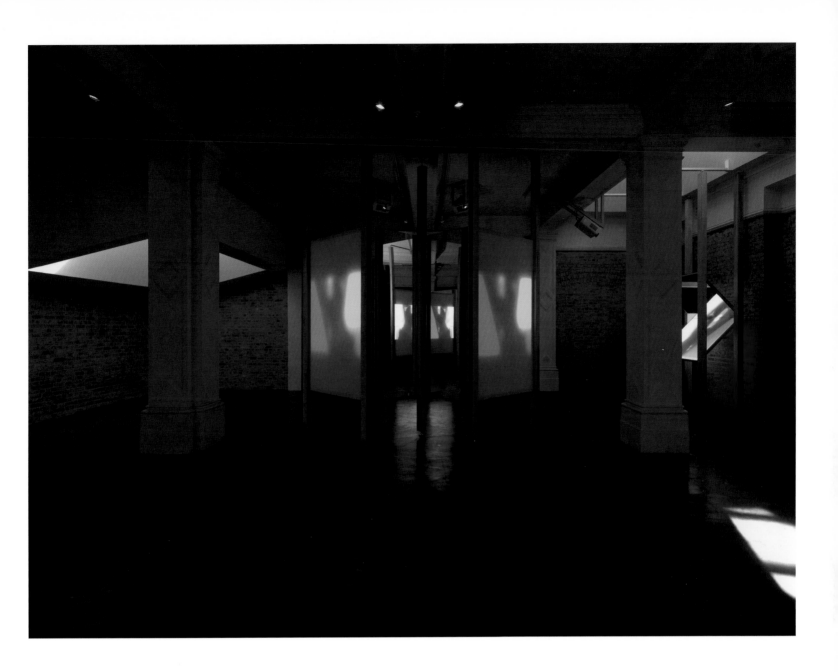

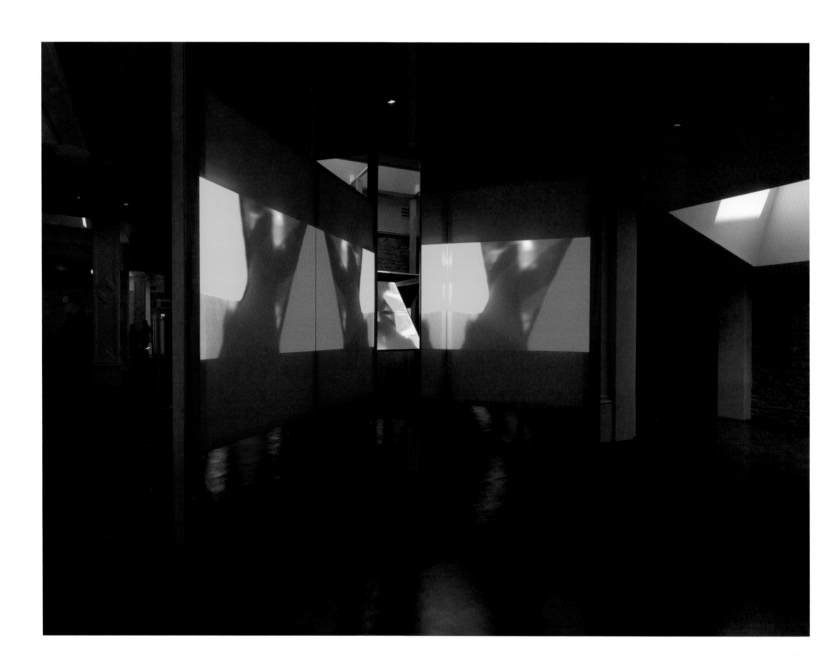

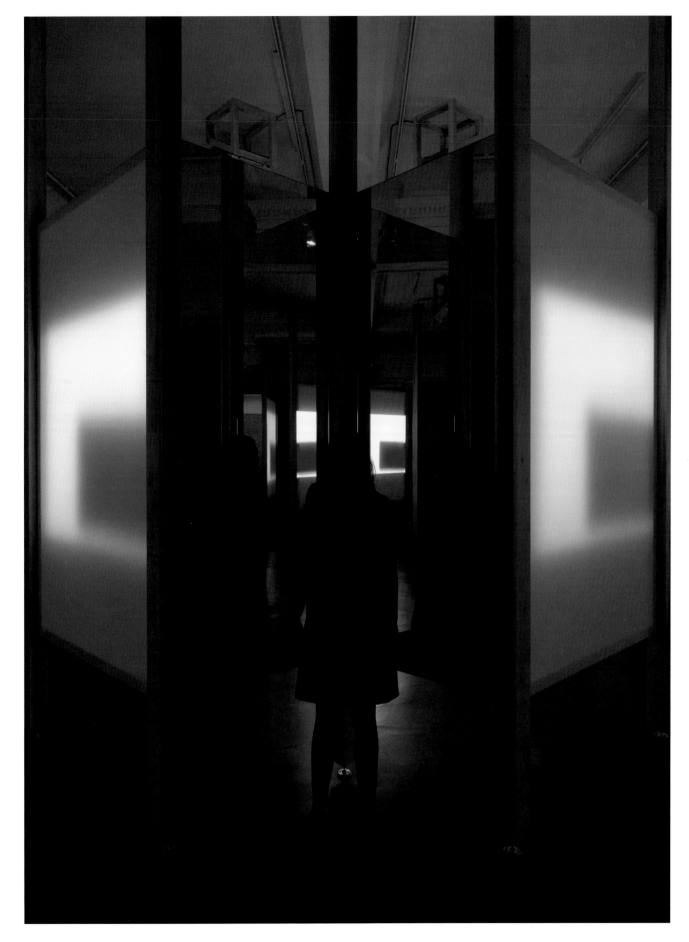

Screen For Observing Abstractions No.4
Wood, mirror, screen material and projection
Two-panel screen construction
Dimensions variable

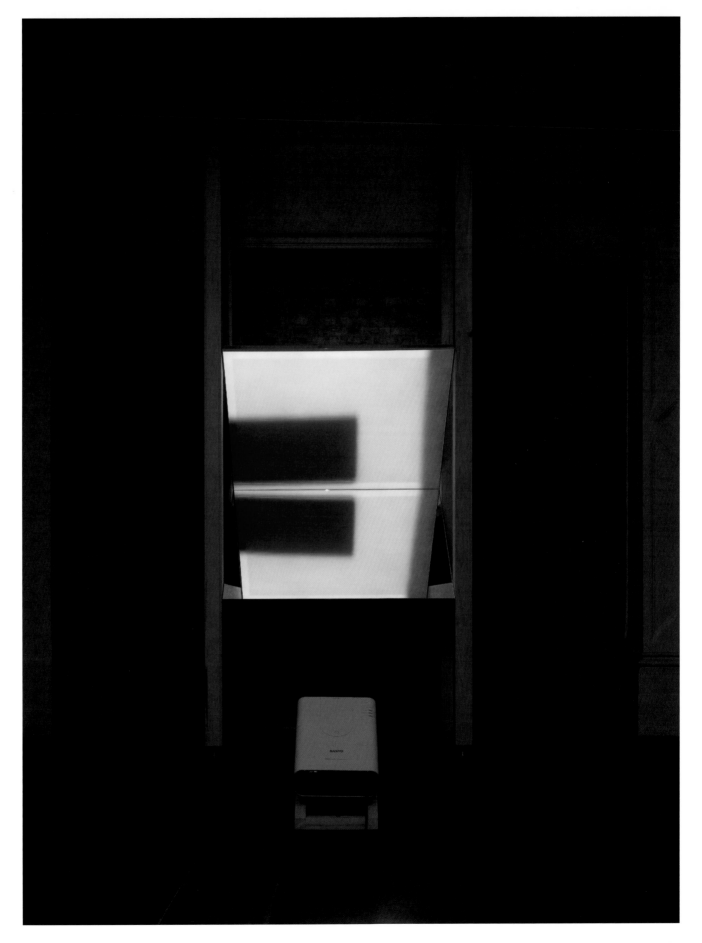

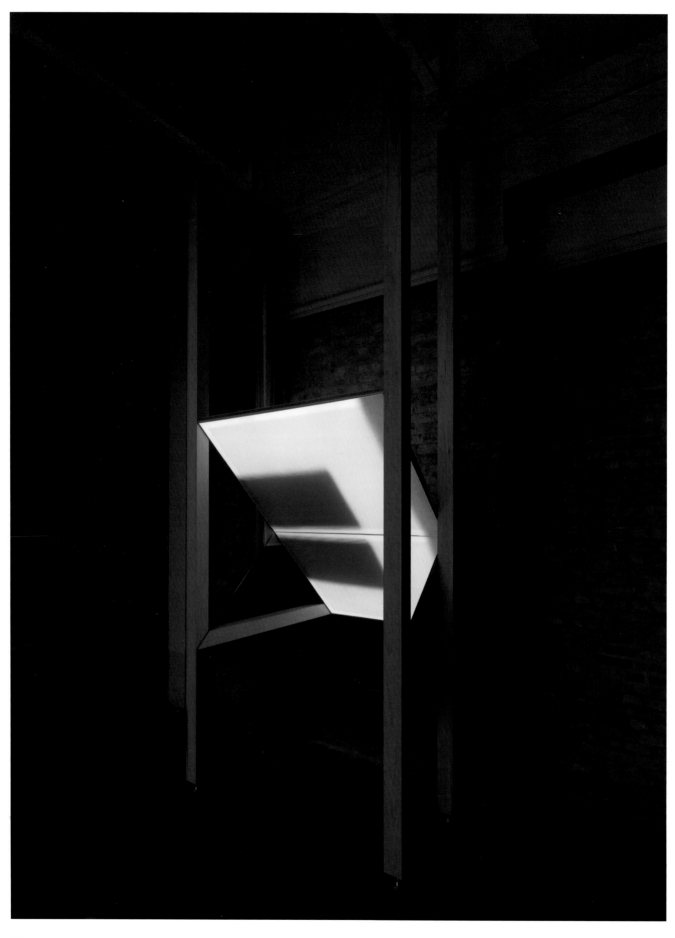

Screen For Observing Abstractions No.5
Wood, mirror, screen material and projection
Four-panel screen construction
Dimensions variable

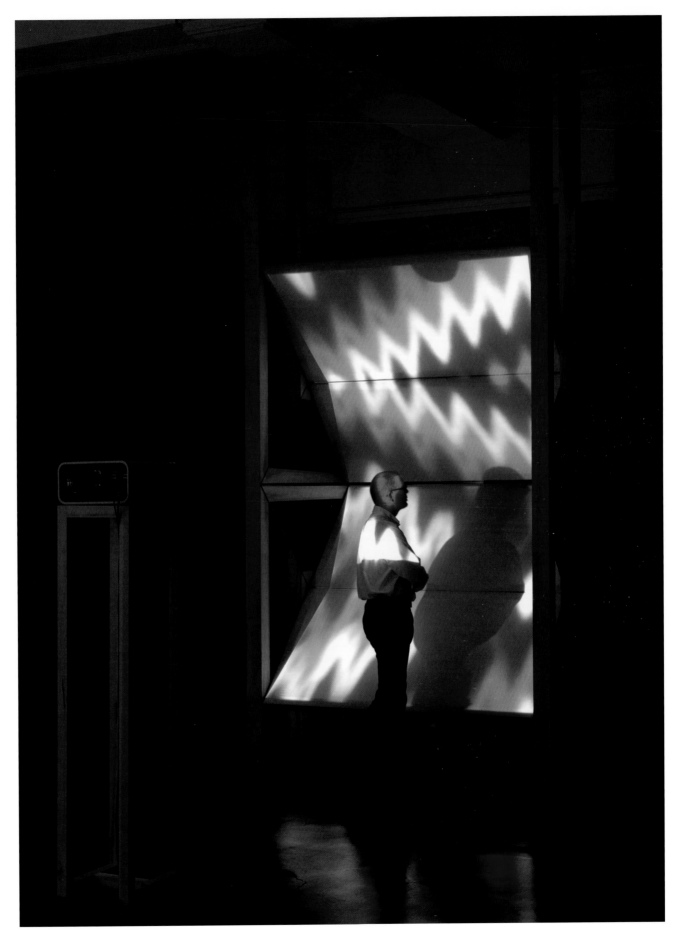

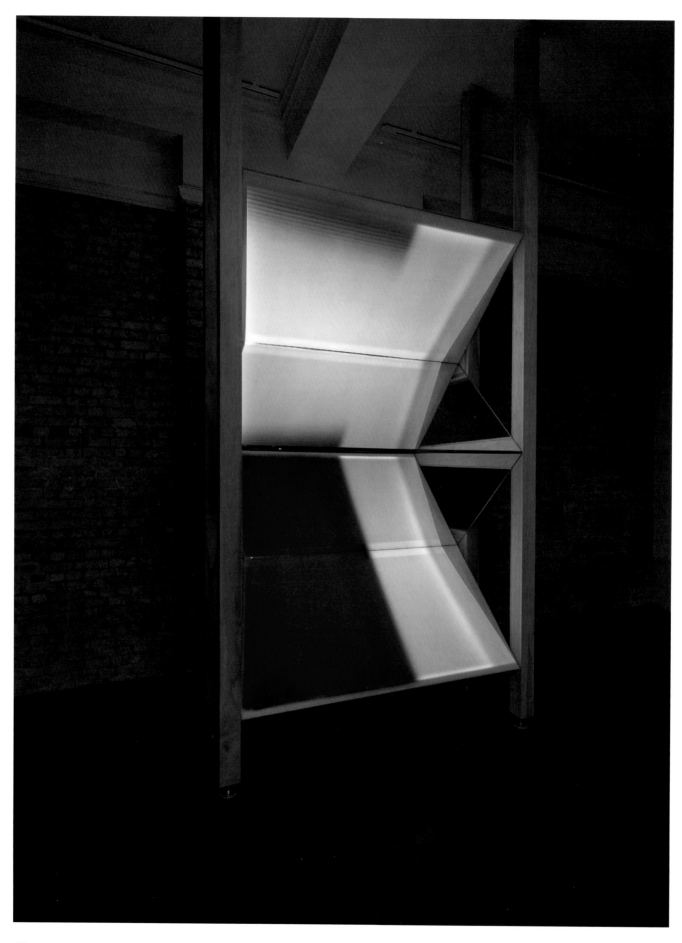

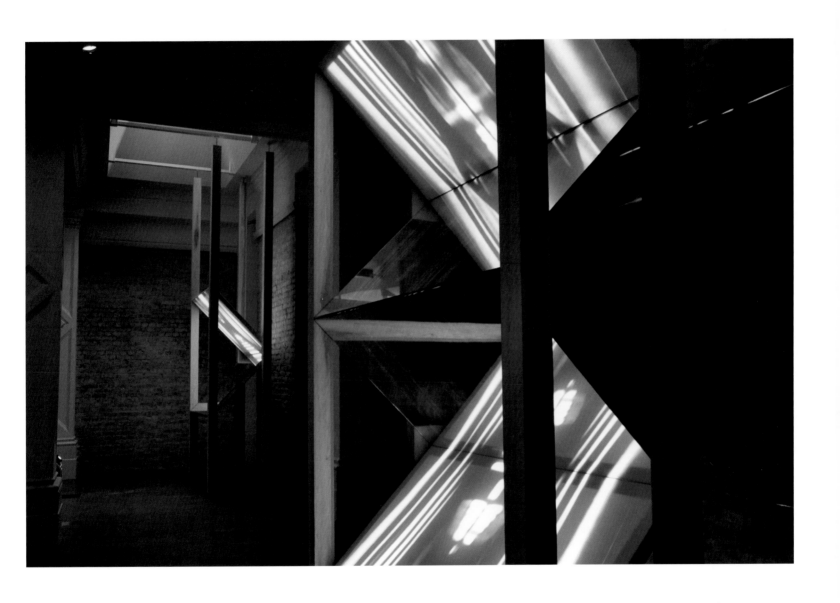

Screen For Observing Abstractions No.6
Wood, mirror, screen material and projection
Four-panel screen with central pyramid construction
Dimensions variable

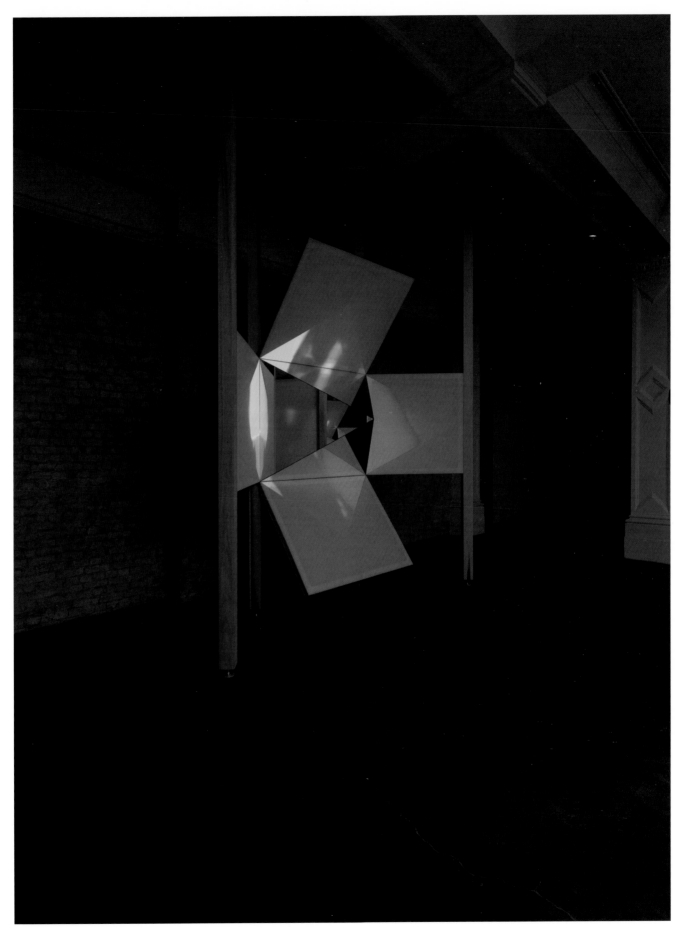

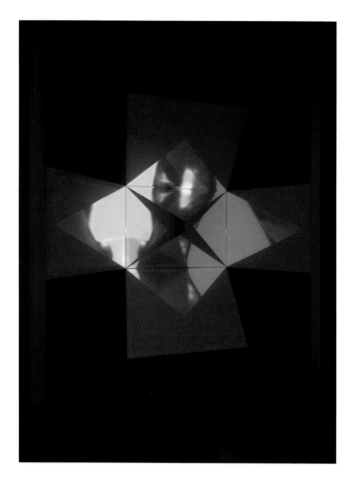
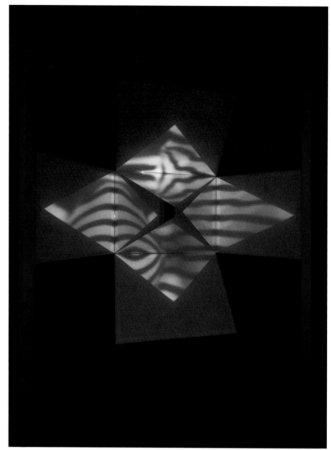
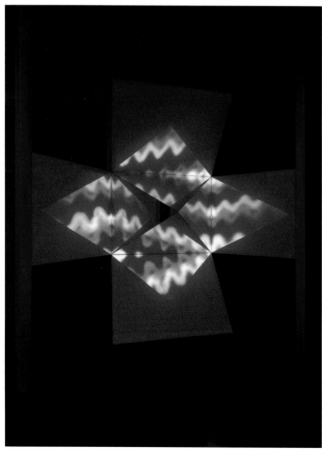
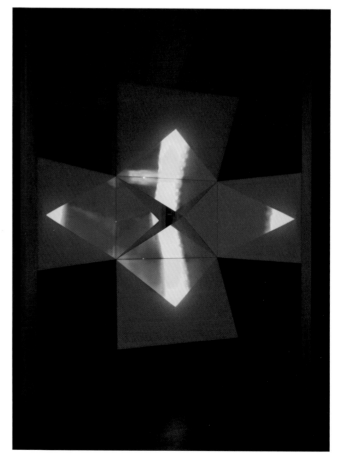

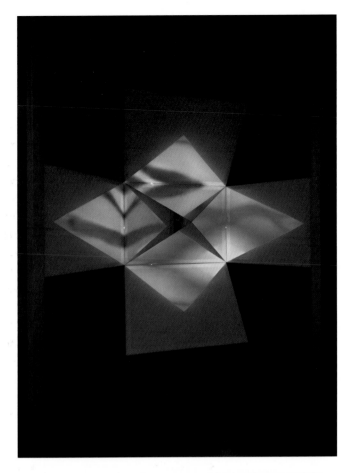
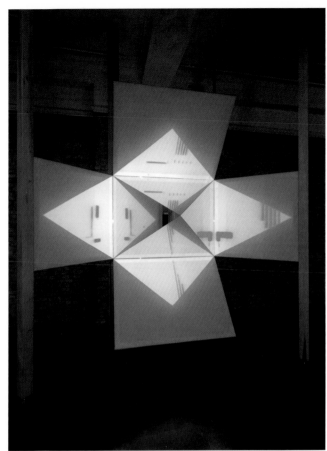
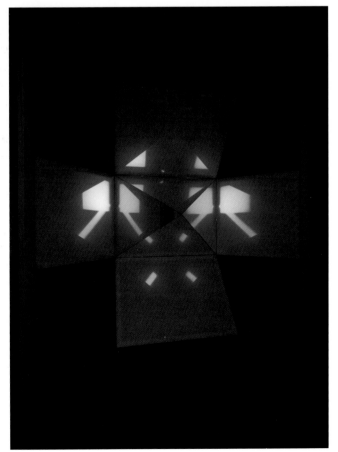
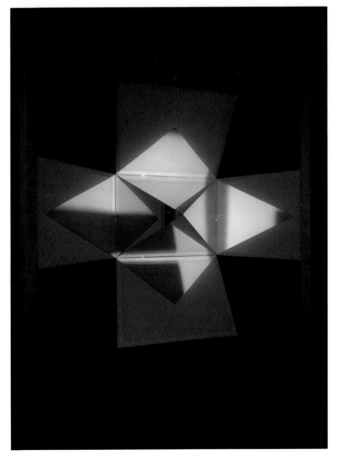

Screen For Observing Abstractions No.7
Wood, mirror, screen material and projection
Two-panel screen construction
Dimensions variable

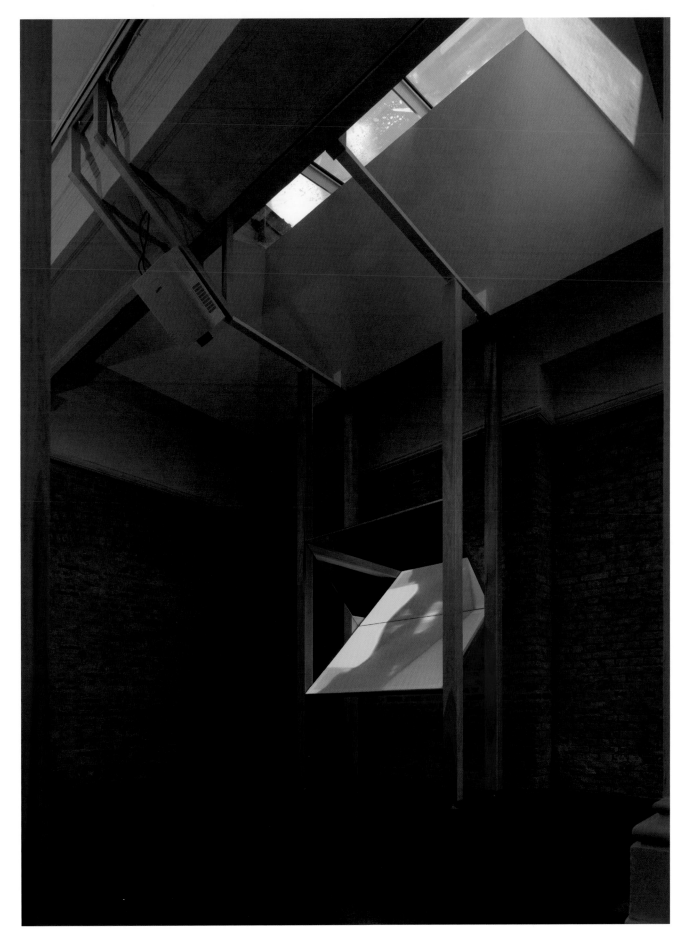

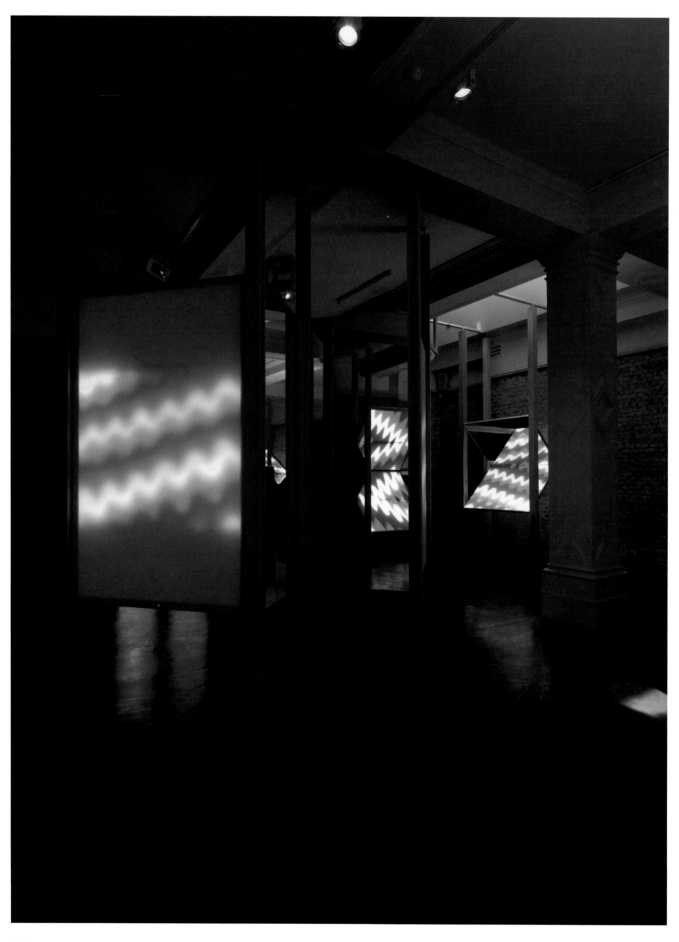

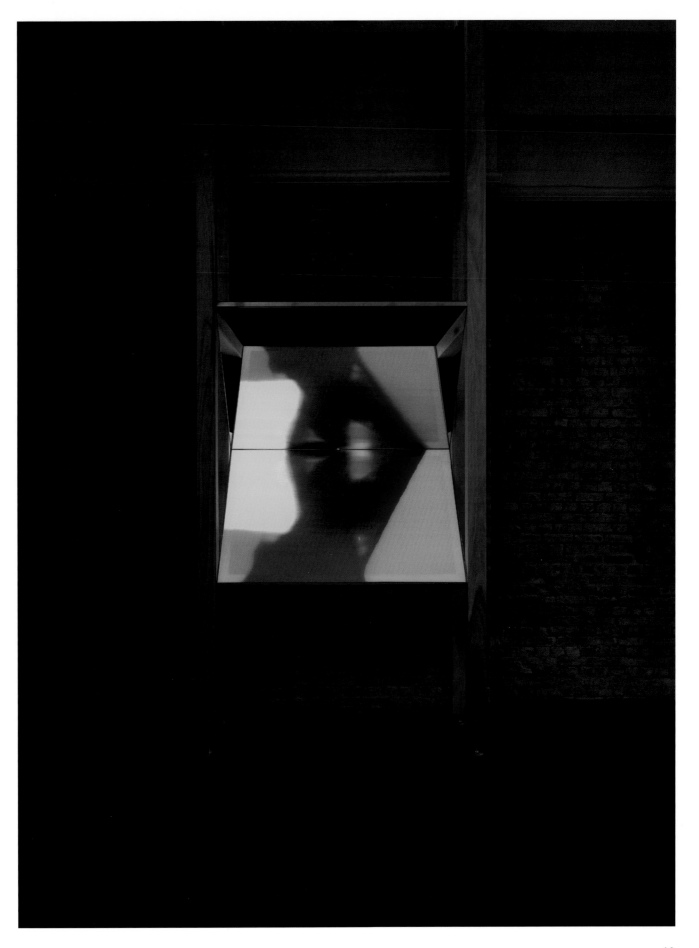

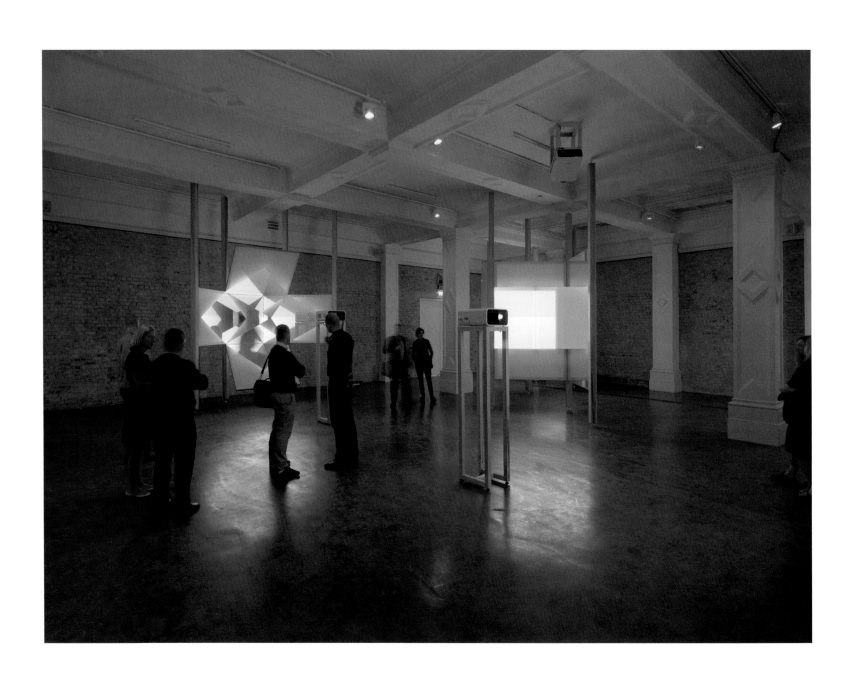

this page, right and overleaf:
Installation views:
Josiah McElheny
The Past Was A Mirage I'd Left Far Behind, 2011-12

70

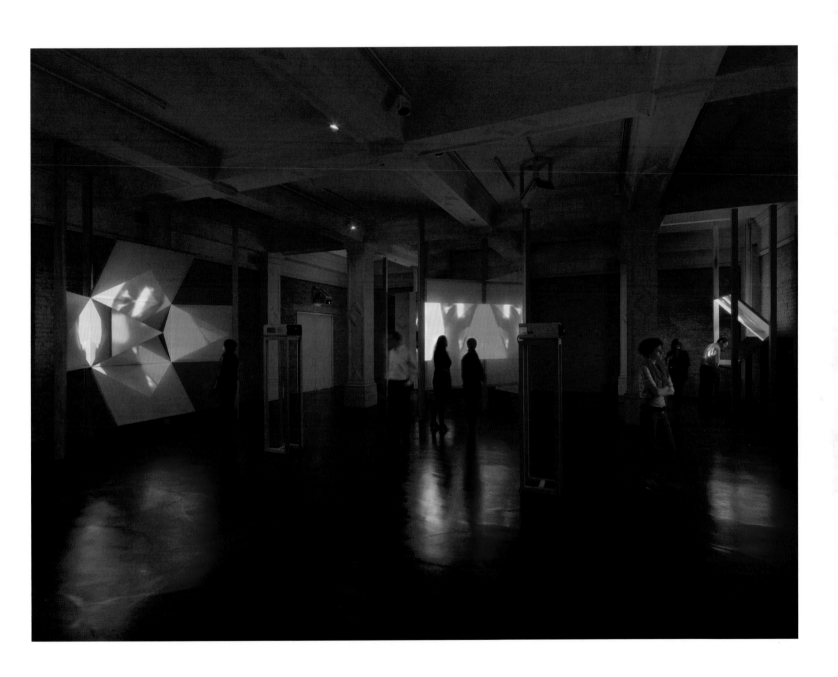

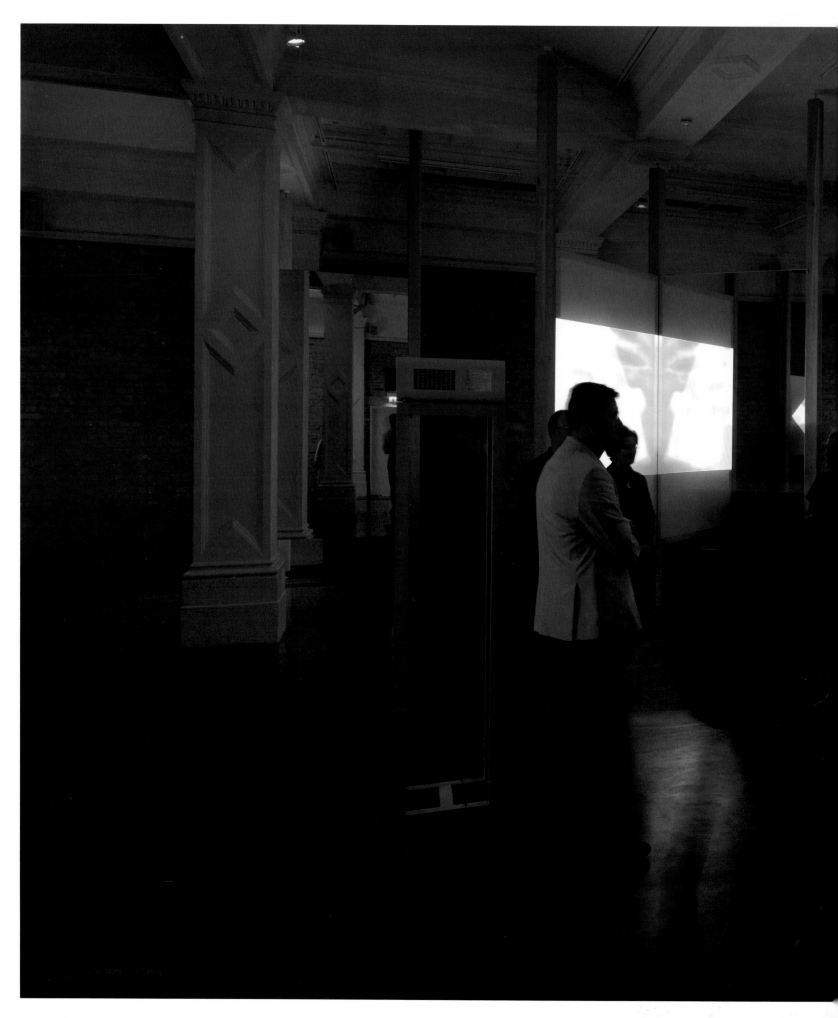

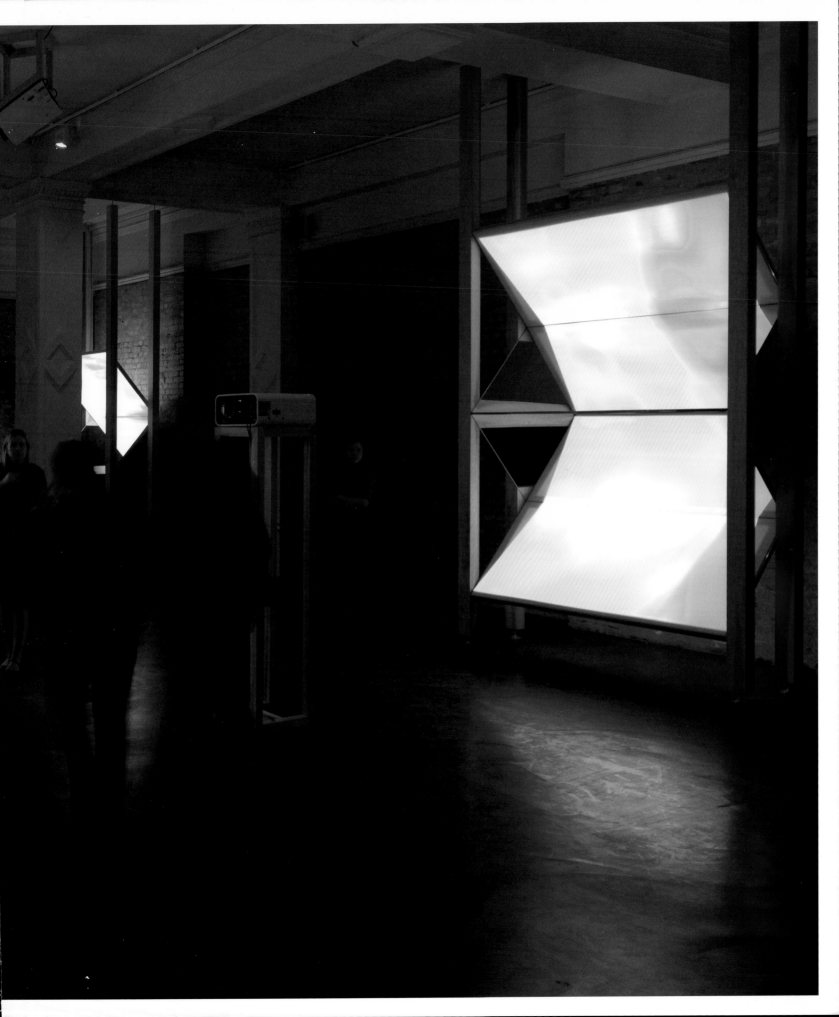

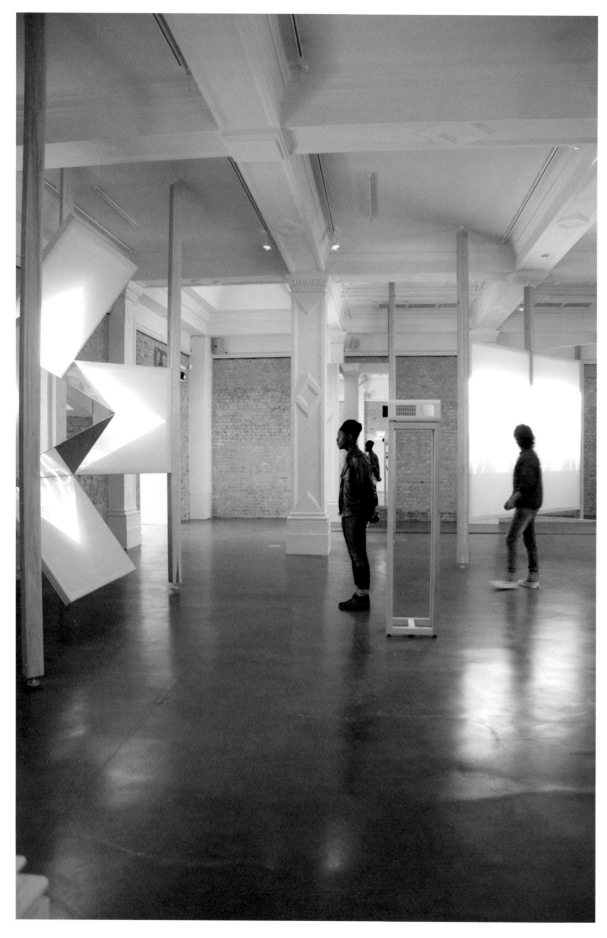

Josiah McElheny
in conversation with
Daniel F. Herrmann
and Tamara Trodd

Daniel F. Herrmann *Josiah, how would you describe* The Past Was A Mirage I'd Left Far Behind *in your own words?*

Josiah McElheny It is a physically multifaceted project. It's seven sculptural screens that refract images and unfold them, or double them, or triple them. Onto these sculptures, I project a history of abstraction in film, from the present day back through the twentieth century. The projections become a collage and they are shown upside down, flipped and in reverse, although the sound continues forward. Each season, there will be a different selection of films, representing four subjective histories of abstraction. Typically, the histories of abstraction in film are confined to specific, short periods when people were creating them for a particular reason or in a particular place; this project looks at it as a broad history, collapsing and overlaying different moments, and perhaps expanding them into something new–today.

What was exciting about this commission was a series of things about the Whitechapel's history that I found fascinating: the relationship of the institution to the neighbourhood, to the history of the labour movement and to the idea of education as a kind of cross-class enterprise–especially because these

left:
Installation view and overleaf:
Josiah McElheny
The Past Was A Mirage I'd Left Far Behind, 2011-12

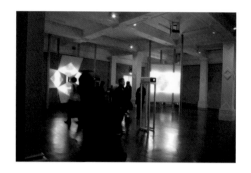

relationships are still so present in the institution. When I found out about the commission's parameters, that it was going to take place in the former reading room of the Whitechapel Library, I immediately began thinking about the idea of an archive and new histories. As I learned more about the institution, working with the curators at Whitechapel, there was also this historical fact that the library had been considered 'a lantern for learning'. In the original architecture there were windowed rooms within the library, also windows that looked out on the street and ceilings that had coloured panels – in my mind's eye I imagined a building built to project light out into the neighbourhood. Thinking about how to work with all this, I wanted to have light projected and refracted within the space. I started thinking about how abstraction has been seen in the past as an ideal related to enlightenment, of a new understanding of the world. Even though this is perhaps a discredited notion, I've been pondering how could we come back to that and find a different way forward through the ideas of abstraction.

Tamara Trodd *Looking at what you have done with this space, it seems to me that you've turned it into a sort of magic lantern – that is, a place of phantasmagoria – as much as a place of learning; perhaps phantasmagoria as a way of learning. What do you think it is that we can learn from this idea of the lantern, or the magic lantern? How do you want to use that as a model for learning from this space of encounter here?*

JM That seems like a key distinction to point out: the difference between being a lantern that's projecting light and a magic lantern that is projecting an image. Perhaps I hope to point to the museum or library as places where history is constructed, why I thought that the Whitechapel Gallery's history is important. Another concept driving the project is creating alternative archives by asking collaborators to comb the history of whatever one defines as abstraction in film and create multiple versions of that history.

In thinking of abstraction as being something conceivably connected with the idea of enlightenment, I wanted to remember to take into account how today this is considered a discredited position. The idea of abstraction is associated with aesthetic models that don't take into account difference: neither in terms of multiple viewpoints, nor in terms of awareness of specific cultural situations. I was wondering how we could look at abstraction again, as something

that has a sense of possibility. Instead of it being a singular, hermetic vision of a singular voice, how could it be fractured in such a way that people could reassemble it as a unique and subjective set of ideas or images that hopefully are more than merely entertaining. I am trying to find out if various kinds of abstract structures can, in and of themselves, have political meaning.

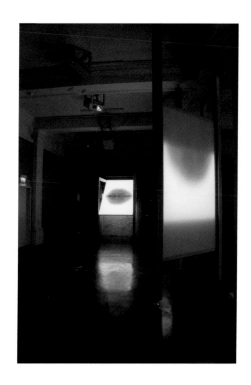

TT *I can see how you want to turn a place of learning into a multifaceted, crystalline, fragmented structure that people can reconfigure in their own subjective ways, in their own standpoints and in a space of activity and learning. But there are also these elements of pleasure, beauty and the kaleidoscopic, which are rendered very powerfully in your installation. You specified to the selectors that the films should be abstract; your reconfigurations of the films on the sculptures produce symmetries and new imagistic relationships between the different films that are on display; the darkened space of the room and the flickering colours that are produced very much evoke shards of light refracted by a crystal. This is a model of visual experience as much as a model of learning, thinking or cognition. It suggests that abstraction, if not as entertainment, then as visual pleasure, is also a way in which you want the viewers to relate to the work.*

JM I don't really believe in a divide between the pleasure of looking from the cognition and inquiry that is an inherent part of looking. I believe in an experience of looking and thinking similar to the famous quote by William Carlos Williams that there are 'no ideas but in things'. The notion that cognition can't happen unless you have the approved or digested text that explains things – I am against that kind of authoritative construction of understanding. It's not that the text isn't important, but I want to assume that what you see can, at least in part, be deciphered through one's own bodily, personal set of observations, knowledge created through subjective physical observations. Knowledge is not authoritative; knowledge is recreated by subjective experience.

TT *I think this also touches on the relationship between the physical sculptural element and the projected image in this particular installation. You have these clear, wooden sculptural elements, which are then married to very reflective surfaces that produce a 'procession of simulacra' effect, a kind of infinity. One could see this as a cinematic reading of Minimalism, relating to Robert*

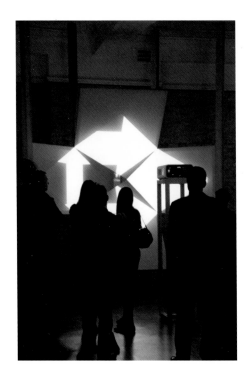

Smithson's reaction to Donald Judd with his own use of mirrors in works such as Enantiomorphic Chambers *(1965). That would be one way of thinking about the relationship between the sculptural element and the film work in this show.*

JM It's interesting that you see this work as conforming to a strict definition of sculpture, like the idea that – going back to Judd – the sculpture is only itself. When you describe a cinematic reading of Minimalism, I think that's something that Judd himself would have absolutely resisted. I think you are right, that a cinematic experience is created by some of those works, but his intention was for objects that stand for themselves and refer to nothing else. My sculptures hopefully don't have that quality of only standing for themselves. While they have a relationship with Minimalism, I want them to have an indeterminate relationship to the films and to the viewer: they don't really exist without the films and maybe not without the viewer who is reflected in them either. The project is not so much a theatre with a single stage, in that you're not standing on one side of it and looking in. Maybe it's more like being inside a camera obscura, inside a space where a moving image is constantly being created, maybe these sculptures create a situation like that. For me, it's really hard to define what the sculpture part is; I hope it is the totality of being in the space.

That's why I am interested in the model of the crystalline as an approach, not so much in terms of it as a symbolic form or its metaphorical meanings, but a configuration that allows – as you move around it and change your relationship to it – for change. But I hope that it's not doing that by imposing its organisation on you, like a space that's gridded. The grid imposes itself upon you, whereas in the crystalline maybe you can see where the surface is, but you're standing still in your own space because you don't know where the crystalline leads to next. I think that this piece functions that way, there are moments of confusion but then there are also moments where you're suddenly grounded. It's constantly changing, but you see the images repeated in different ways and realise: 'Well, actually, what really counts is not what's happening on the sculpture, or in the sculpture, or in the image, but what I'm doing with it, and where I decide to go or to look.'

DH *Which means that the beholder, the viewer, gets to play a different part in the exhibition than he or she would with, say, traditional panel painting. Can you elaborate on that?*

JM Basically, there is no ideal view of any of these sculptures, and they are about what happens over time according to the position of the person's body. You could say that no two people will see the same thing, and that you can make new narratives as you walk through the exhibition. Maybe that sounds pretentious, but I think that there is an aspect of it that's true. One of the first things you try to figure out is how these very simple objects are making complex images. Also it's not a dark space, it's a dimly lit space, because of that you sense that you are inside of and part of an exhibition not a cinema – the projectors are placed in such a way that sometimes you're blocking the image and adding your own image or silhouette in order to see the images. Particularly in one sculpture where there's a sort of infinite, widescreen, duplication of the image – to really look at it you end up casting your shadow or your silhouette on it. You become another abstract form on the screen and in the mirror. As well, when you're looking around the exhibition, other visitors are adding their image to the vista, and because the light is behind them, they become very stark silhouettes against the other images. Because it uses moving projections, what's happening is constantly changing, temporary, which to me suggests that it's really about the people who are there and their perception, more than it is about these things as independent objects.

TT *I was wondering, like Daniel, what kind of viewing you're hoping this work will provoke. And I was thinking that there are different possible models that come from your previous works and may be appropriate here. 'Play' would be one of them, where the audience can see their reflections and then dodge and hide and be surprised by a reflection they didn't expect – a little bit like in a hall of mirrors in a fairground. Looking at this particular installation, with its framed, upright screens on 'platforms', I was also reminded of the (now rather outdated) look of another kind of play space, the video arcade where individual players gaze into upright screens whose colours are reflected onto their rapt and absorbed faces. Other models would be that of the carnival, like the way that in* The Metal Party *you were interested in the euphoric, a wild and potentially disruptive kind of pleasure that arose as the participants experienced the noises of their costumes and their interaction with the soundtrack. I wonder what you think about how the viewer might relate to this work, perhaps in light of these suggested references.*

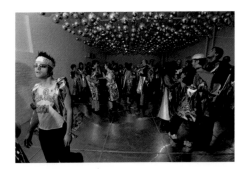

Josiah McElheny
The Metal Party: Reconstructing a Party at the Bauhaus in Dessau on February 9, 1929, 2001
A participatory performance project held in New York by Public Art Fund and Yerba Buena Centre for the Arts, San Francisco, November 2001. Installation view: ongoing party site for *The Metal Party* after opening night in New York.

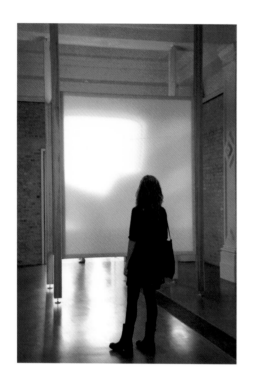

JM One of the things I've learnt from making art is about control, that it is impossible to control or even predict what will be the possible responses to an artwork. In fact to me, the impossibility of predetermining what interpretations will arise is one of the great things about art. When I did *The Metal Party*, I had free drinks, free costumes that fit over everybody's clothing and dancing, and all that was required was that you show up and meet your friends and have a drink and dance while wearing this costume. I thought I was being so clever, that I had figured it all out and had everything under control. But then it turned out that everybody rebelled. People shredded their costumes, tore them apart, and the rebellion was definitely the best part of the performance.

I don't know what people will make of the commission, and I can only say what I would hope. I guess that your bringing up the idea of the carnival is apropos, there is an idea of fantasy or play or imaginary space that I'm interested in and for me those notions are symbols for thinking about history, society and the future. I remember as a kid going to video arcades and the sense of possibility when you walked through the space, that each of these machines could represent some kind of portal or entry to someplace else, and how fantastic it was that they were all in this particular, physical place that you could visit. But I was never interested in playing those games because they were actually all about controlling your response to them: 'OK, yes, we're going to describe this world but you are going to think about it in such and such a way', and if you don't accede to that, you get it wrong and the screen says 'Game Over'.

I hope that what I am trying to do is different from a video arcade or carnival, that it's more like the pleasure one may get from browsing through the book stacks in a library. I guess that's now an old-fashioned library, where the stacks are organised in a classification system but at the same time that system allows for an incredible set of unintended juxtapositions: the feeling that by simply choosing to look at books on the third shelf, then the fourth shelf, then the shelf to the left of that one, that you create unique juxtaposition of ideas. I want this project at Whitechapel to feel more like that, as opposed to a space of entertainment and inflexible rules – that you can see how it's put together but then you can still make up your own rules.

DH *There is a certain open-endedness that is also reflected in the ongoing element of the installation. Over the course of the year, you invite a number of other people, or collectives of people, to screen films onto the sculptures.*

JM Part of my experience of learning what it is to be an artist has included a growing awareness that it's a collective enterprise. As well, I feel that my life as an artist is about learning. I've never been satisfied with my level of understanding, and I'm often struck by how the mistakes I make and the mis-understandings that I have are so illuminating for me, and so exciting. For me, the more you engage with other people, the more opportunity there is to test one's own misunderstanding. So I really like to try to create a situation that inherently requires collaboration, whether through writing, or curating, or collaborating directly on a work. Those are all moments of learning for me.

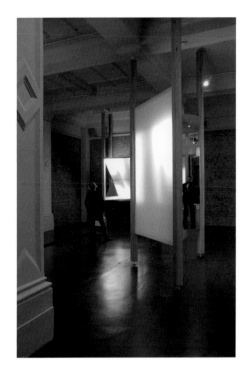

By inviting others to be involved, I don't feel like I'm giving up control, although of course in some ways I am. When I saw the choices made by our first collaborator, Kenneth Goldsmith, on a standard computer screen, one after another sequentially, I was nervous. I wasn't sure that it was going where I was hoping it would go. I had a moment of doubt that maybe this won't work. Of course, I hope that Kenneth reading this – if he ever reads this – would understand this moment of doubt, because now I can't imagine anything better than the sequence he created. I was surprised at the amount of serendipity in how it works on the seven sculptures – he couldn't have anticipated the ways that his selections would interrelate in this situation – and how the reconfigured films function to create a different sense of time. Ultimately I learned what the project is about for me from his contribution – it's about how abstraction, espe-cially moving abstraction, can change one's awareness of time. For me, that's one of the most important roles that contemporary art has at this point: it can provide experiences of various alternative timescales, in opposition to pure speed and pure efficiency.

TT *The way you engage in collaborations is very interesting, because although this installation is an example of an open collaboration, I'm very struck by the way that you do control the contributions in certain specific ways. You reverse the chronological order of the films in each series. And you screen the films backwards, you flip the image, and you show it upside down. In all of those ways, it could be argued that you, the artist, reassert a certain amount of control over the programme of films that's supplied. I'm interested in that because I have noticed the ways that in previous works your collaborations have often focused on antagonistic examples of collaboration, or examples of what we could call 'misreading', where you've put Mies van der Rohe's glass skyscraper into collision with Bruno Taut's 'chromatic Modernism' – the term you used in the title of your*

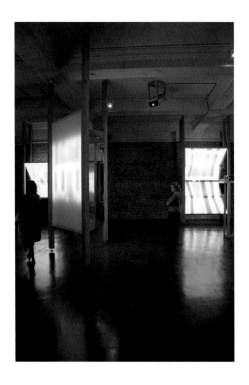

exhibition Proposals for a Chromatic Modernism *at Andrea Rosen Gallery, New York, in 2009. In doing so, you drew out the ways in which they represent different models of abstraction. You also grew interested in* The Metal Party *with the ways that the participants resisted the control of the soundscape by adding their own noise. So that even whilst you want to create a situation of open collaboration, it strikes me that you're not interested in it just being purely benign, you're interested in strongly misreading and counterposing possible ways of reading works of art, or producing antagonistic meaning out of the situations that you set up.*

JM Yes, all those comments hit close to home. Maybe that's kind of a personal interest that I have; a predilection to, as you put it, create a particular kind of conflict, or to create this space where things hit against each other. From my perspective this connects to how art functions for me, that one of my favourite things about art is that something you hated you could grow to love, and something that you loved you could grow to hate – the opportunity for thought and change. That's just how I see artwork, or how I myself experience looking at art.

DH *I would like to talk a little bit about the subject of your collaborative investigation for this work: abstract film. What is your particular interest in abstraction?*

JM I'm interested in abstraction because it's a physical system, or language, that in theory could allow one to imagine a new world. There are many different artistic approaches – realism or satire, for example, are absolutely crucial – but it's also very important, and art has often thought about this, to imagine a new future. In the past that has oftentimes meant a future in which you erase the past itself and begin again – that is part of the origins of abstraction. But I'm very interested in whether we could take abstraction and imagine a new world that's built out of the fragments of an explosion, or out of a fracturing, or as a set of infinite possibilities – as opposed to a summing up, clarifying or simplifying everything.

 It seems that with narrative it's very difficult to detach yourself from what you already know. There's something about abstraction that allows you to think and sense with the body in a way where you can, for a moment, let go of your normal train of thought, and perhaps shift, at least for a second, the direction of your thoughts. Abstraction seems to me like it still has that possibility, even

though it's been tainted by its association with various totalizing and destructive aspects of what happened in the history of the twentieth century.

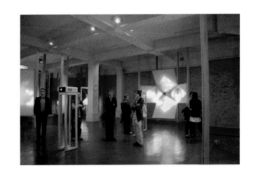

TT *What are the possibilities – the kinds of utopian aspirations – that you're looking to connect to with this new interest in modernist abstract film?*

JM Without hopefully offending people who dedicate their efforts towards it, I think that abstract film is a kind of stepchild: it's never been at the center of the history of abstraction or Modernism, or film more broadly. I'm attracted to things that are like that because it feels like then you can say something new, that it's more likely for you to be able to shift a view of something like that. If for instance, I were to take the history of Barnett Newman's ideas of abstraction, it would be very difficult to claim, or even entertain the notion, that I could shift anything about that. So for me, abstraction in film functions as a kind of off-the-beaten-track subject, but that has important things to contribute. The Whitechapel project is a big experiment for me. Part of the reason to collaborate with other people is that I'm not any kind of expert, even quasi- or amateur, in the history of abstraction in film. So it made more sense to me to collaborate, to try and connect and maybe expand that history.

Another thing that surprised me is that the project may end up connecting more to the history of Robert Smithson, Bruce Nauman, Isa Genzken or Dan Graham, than it does the history of film. Perhaps it has more to do with Smithson's piece *Mirage No. 1* (1967), where as you walk alongside the sequence of mirrors reflecting exactly the same thing the whole time, still your sense of where you are is changed as you go along it step by step. Or perhaps it does a kind of dramatic version of what Graham claims for his pavilions, where you see yourself seeing yourself and seeing others. I feel that this is the only sculptural project I'd ever done that is not complete without the people in it. I don't mean just the people's perception; I mean that you see other people in the space while you're there – it's such a key part of it.

Often when you see films from this history presented in a cinema, where you have to come in and sit down and look at the film – in theory from beginning to end – they feel hermetic. They seem like an abstraction that you have to submerge yourself in, according to its rules. I think that that's not necessarily the way it was when these films were first made, but that's how they appear now. This project is a way of hopefully shifting that feeling, so that people re-see these works and find a sense of possibility in this genre of abstraction. But I'm

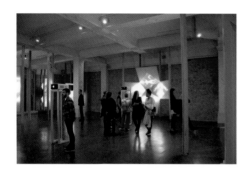

also aware that I'm both celebrating these films and destroying – or disassembling – them. That's why it's important that the history of abstraction in film is enunciated publicly in the explanatory parts of the exhibition, such as the little annex room, and that we want to also show the films which were the basis for the reconfigured projections in the gallery auditorium, as a corollary event. That's very important as a memory or counterbalance to how I have reassembled aspects of these films in order to make something else. In my project, they retain many of their original qualities, but I'm aware that I have re-collaged them into something that they were not originally.

right:
Installation view:
Josiah McElheny
The Past Was A Mirage I'd Left Far Behind, 2011-12
Letter from Josiah McElheny to Kenneth Goldsmith, 14 August 2011

Kenneth Goldsmith
UbuWeb

August 14th, 2011

Dear Kenneth,

I am writing to you with a request for your help in an upcoming exhibition project.

As you may know, the Whitechapel Gallery annually exhibits the Bloomberg Commission, for which a newly created work is displayed in the historic space of the former Whitechapel Library, now part of the extended Gallery.

As the artist for this year's commission, I want to take the opportunity to use the history of the exhibition space as a starting point for exploring the way we observe history as moving form and information. Often described as a 'lantern of learning' and having played a key role in the formation of British abstraction, the Whitechapel Gallery's former Library seems particularly interesting for looking into the history of abstract moving images.

The installation for the Bloomberg Commission, *The Past was a Mirage I'd left far behind,* consists of seven sculptural screens made from mirror, wood and cloth, solely for the projection of choreographed series of extant abstract films. Refracting, doubling, folding and extending any image projected onto them, the sculptures will illuminate the exhibition space itself. As well, they will put the beholder into the picture: looking at the images, the viewer will encounter her own shadow, silhouette and image, interacting with the refractions and extensions of the moving abstractions she observes. There can be no objectivity of historical observation; perhaps these sculptures may form a physical manifestation of history that acknowledges the observer's subjectivity.

The project hopes to explore non-canonical histories of abstract film, creating new associations across the past 90 years, or making better-known historical examples relevant to the contemporary. In this light, we are asking four different scholars (or collaborative groups) to select a reel of films; over the year-long exhibition these different perspectives and emphasis may suggest a broader historical category of moving image abstraction but also new meanings for the endeavor itself.

I am very interested in the way your work has investigated artistic agency, and would very much like to ask you to participate in this project by selecting a personal history of abstract film, which will form the basis for a choreography that will be projected onto the sculptures. We will also be screening your selections as a special evening in the auditorium at the Whitechapel Gallery.

Please have a look at the attached information regarding the selection of these films.
This project is intended to be a collaboration with historic film and contemporary thinkers and I would be so honored if you would be willing to be a part of it by contributing your own personal history of abstraction.

Sincerely,

Josiah McElheny

Josiah McElheny

Born 1966, USA
Lives and works in New York City

2001 *Works 1994–2000*, Gallery of Art at Johnson County
 Community College, Overland Park, Kansas
 The Metal Party, The Public Art Fund, New York and
 Yerba Buena Center for the Arts, San Francisco
2000 *Christian Dior, Jorge Luis Borges, Adolf Loos*, Donald
 Young Gallery, Chicago
 Brent Sikkema, New York
1999 *The Story of Glass*, The Isabella Stewart Gardner
 Museum, Boston
 An Historical Anecdote About Fashion, Henry Art
 Gallery, University of Washington, Seattle
1997 *Non-Decorative Beautiful Objects*, AC Project Room,
 New York
1996 *Three Alter Egos*, Donald Young Gallery, Seattle
 Barbara Krakow Gallery, Boston
1995 Donald Young Gallery, Seattle
 Seattle Art Museum, Seattle
 Stephen Friedman Gallery, London (with Adam Rolston)
 Andrea Rosen Gallery, New York (with Dan Peterman)
 Grazer Kunstverein, Graz (with Dan Peterman)
1994 *Authentic History*, Robert Lehman Gallery, Brooklyn,
 New York
1993 *originals, fakes, reproductions*, William Traver Gallery,
 Seattle
1990 Jägarens Glasmuseet (The Hunter's Glass Museum),
 Arnescruv, Sweden

Selected group exhibitions

2011 *Two Fold*, The Suburban/The Poor Farm, Oak Park,
 Illinois
2010 *Contemplating the Void: Interventions in the
 Guggenheim Museum Rotunda*, Solomon R.
 Guggenheim Museum, New York
 JAMES HYDE, Redi-Mix, Kathleen Cullen Fine Arts,
 New York
 Face Your Demons, Milliken Gallery, Stockholm
2009 *Allan Kaprow YARD*, Hauser & Wirth, New York
 Universal Code, The Power Plant, Toronto
 *Sense and Sentiment. Mistakes are closely followed
 by Effects*, curated by Eva Maria Stadler and Sabeth
 Buchmann, Augarten Contemporary, Vienna
 *Innovations in the Third Dimension: Sculpture of our
 time*, curated by Nancy Hall-Duncan, Bruce Museum,
 Greenwich, Connecticut
2008 *Objects of Value*, curated by Rene Morales, Miami
 Art Museum, Miami
 Multi-Part Art, Contemporary Works from the

Collection, Museum of Art Rhode Island School of
Design, Providence, Rhode Island
Mildred's Lane, curated by J. Morgan Puett and Mark
Dion, Alexander Gray Gallery, New York
Spring-Wound, Orchard, New York
Beyond Measure: Conversations Across Art and Science,
Kettle's Yard, University of Cambridge, Cambridge
*Sensory Overload: Light, Motion, Sound and the
Optical in Art Since 1945*, Milwaukee Art Museum,
Wisconsin
2007 *Viewfinder*, Henry Art Gallery, University of Washington,
 Seattle
 Sparkle Then Fade, Tacoma Art Museum, Tacoma,
 Washington
 Cosmologies, James Cohan Gallery, New York
 Accumulations: More Than the Sum of Their Parts,
 Institute of Contemporary Art, Boston
 Museo de reproducciones fotograficas, Rutgers
 University Gallery, Newark, New Jersey
2006 *The Bong Show (or This is Not a Pipe)*, Leslie Tonkonow,
 New York
 Transitional Objects: Contemporary Still Life, Neuberger
 Museum of Art, Purchase, New York
 Dynasty, Gallery MC, New York
 Super Vision, Institute of Contemporary Art, Boston
 Shiny, Wexner Center for the Arts, Columbus, Ohio
2005 *Part Object Part Sculpture*, Wexner Center for the Arts,
 Columbus, Ohio
 Faith, Real Art Ways, Hartford, Connecticut
 Spectrum, Galerie Lelong, New York
 Bottle: Contemporary Art and Vernacular Tradition,
 Aldrich Contemporary Art Museum, Ridgefield,
 Connecticut
 *View Eight: A Few Domestic Objects Interrogate a Few
 Works of Art*, Mary Boone, New York
 Extreme Abstraction, Albright-Knox Art Gallery, Buffalo,
 New York
2004 *The Cobweb*, Centro Galego de Arte Contemporánea,
 Santiago de Compostela
 Printemps de septembre á Toulouse: In Extremis,
 Les Abattoirs, Toulouse
 Glass, Rhode Island School of Design Museum,
 Providence, Rhode Island
 Signs of Being, The Foundation To-Life, Inc., Mount
 Kisco, New York
2003 *Books and Manuscripts*, Volume Gallery, New York
 Borges Exhibition, Volume Gallery, New York, New York
 Warped Space, CCA Wattis Institute for Contemporary
 Arts, San Francisco, California

Traces of Light, Centro Galego de Arte Contemporánea, Santiago de Compostela
Living with Duchamp, The Tang Teaching Museum and Art Gallery, Skidmore College, Saratoga Springs, New York
Once Upon a Time: Fiction and Fantasy in Contemporary Art, Selections from the Whitney Museum of American Art, New York State Museum, Albany, New York
Donald Young Gallery, Chicago

2002 *View Six: Surface to Surface*, Mary Boone, New York
Keep in touch, Brent Sikkema, New York
Family, The Aldrich Contemporary Art Museum, Ridgefield, Connecticut
The Photogenic, Institute of Contemporary Art, University of Pennsylvania, Philadelphia, Pennsylvania
Artists to Artists: A Decade of The Space Program, Ace Gallery, New York

2001 *Lateral Thinking: Art of the 1990s,* Museum of Contemporary Art, San Diego, California (travelled to Colorado Springs Fine Arts Center, Colorado Springs, Colorado; Hood Museum, Dartmouth University, Hanover, New Hampshire; and Dayton Art Institute, Dayton, Ohio)
Musings: Contemporary Tradition, Gallery 312, Chicago
Beau Monde: Toward a Redeemed Cosmopolitanism, Fourth International Biennial, SITE Santa Fe, Santa Fe, New Mexico
House Guests: Contemporary Artists in the Grange, Art Gallery of Ontario, Toronto, Ontario
BodySpace, The Baltimore Museum of Art, Baltimore, Maryland
Donald Young Gallery, Chicago
Heart of Glass, Queens Museum of Art, New York
Summer 2001, Brent Sikkema, New York

2000 *2000 Biennial*, The Whitney Museum of American Art, New York
Exhibition Room: Francis Cape, Josiah McElheny, and Yinka Shonibare, Real Art Ways, Hartford, Connecticut
From Here to There – Passageways at Solitude, Akademie Schloss Solitude, Stuttgart

1999 *Patentia,* Nordic Institute of Contemporary Art, Stockholm, Sweden
Building Histories, Apex Art, New York

1998 *At Home in the Museum*, The Art Institute of Chicago, Chicago
Usefool, Postmasters Gallery, New York
Personal Touch, Art in General, New York
Young Americans: Part II, The Saatchi Gallery, London

Inglenook, Feigen Contemporary, New York, New York (travelled to Illinois State University Galleries, Normal, Illinois)
Interlacings, Whitney Museum of American Art at Champion, Stamford, Connecticut

1997 *Paul Bloodgood, Paula Hayes, Josiah McElheny, Sandra Vallejos*, AC Project Room, New York
Living Room, Barbara Westerman Gallery, Newport, Rhode Island

1996 *The Last Supper*, Donald Young Gallery, Seattle
A Labor of Love, The New Museum of Contemporary Art, New York
What's Love Got to Do With It?, Randolph Street Gallery, Chicago
Drawings from the MAB Library, AC Project Room, New York

1995 *VER-RÜCKT*, Kulturstiftung Schloss Agathenburg, Agathenburg, Germany (travelled to Art Museum of Arolsen, Arolsen; Kunsthaus Hamburg, Hamburg)
Holding the Past, Seattle Art Museum, Seattle
Stephen Friedman Gallery, London (with Adam Rolston)

1994 *Are You Experienced?*, Andrea Rosen Gallery, New York
First Fundraising Exhibition, American Fine Arts Company, New York
Wunderkammer, Rena Bransten Gallery, San Francisco, California

Bibliography

Selected monographs and exhibition catalogues

2012 Johanna Burton, Lynne Cooke, Josiah McElheny (eds.), *If you lived here, you'd be home by now*, (Annandale-on-Hudson: CCS Bard).
The Bloomberg Commission: The Past Was A Mirage I'd Left Far Behind, (London: Whitechapel Gallery). Texts by Lisa Le Feuvre, Daniel F. Herrmann and Tamara Trodd.

2010 Josiah McElheny, *The Light Club*, Chicago, (London: University of Chicago Press).
Louise Neri and McElheny Josiah, (eds.), *Josiah McElheny: A Prism*, (New York: Rizzoli).

2009 Lynne Cooke (ed.), *Josiah McElheny: A Space for an Island Universe*, (Madrid: Turner).

2008 Craig Burnett et al., *Island Universe*, (London: Jay Jopling/White Cube).
Josiah McElheny and Erin Shirreff (eds.), *The Light Club of Batavia*. Self-published. Texts by Gregg Bordowitz, Andrea Geyer, Georg Hecht, Josiah McElheny, Ulrike Müller, Paul Scheerbart.

2006 Helen Molesworth (ed.), *Notes for a Sculpture and a Film*, (Columbus: Wexner Center for the Arts, The Ohio State University). Texts by Josiah McElheny, Helen Molesworth, and David Weinberg.

2002 Apollonia Morrill, (ed.), *Josiah McElheny: The Metal Party*, (New York: The Public Art Fund; San Francisco: Yerba Buena Center for the Arts). Texts by Glen Helfand, Christine Mehring, Peter Nisbet and Ingrid Schaffner.
Josiah McElheny, (Santiago de Compostela, Spain: Centro Galego de Arte Contemporánea). Texts by Miguel Fernández-Cid, Miwon Kwon, Louise Neri, and Michael Tarantino.

1999 *Josiah McElheny*, (Boston: The Isabella Stewart Gardner Museum). Texts by Jennifer R. Gross, and Dave Hickey.
An Historical Anecdote About Fashion, (Seattle: Henry Art Gallery). Texts by Richard Martin, Victoria Milne, Ingrid Schaffner and Mark Wigley.

Selected reviews, articles, and publications

2011 Maggie Taft, 'Josiah McElheny', *Artforum* (February) 235

2010 Steve Barnes, 'Mirror Mirror', *ArtNEWS* (June) 26
Jean Robertson, Craig McDaniel, *Themes of Contemporary Art: Visual Art after 1980*, (New York: Oxford University Press).

2009 Lynne Cooke and Josiah McElheny, 'A Conversation about Overlapping Cultural Histories of Production in Art, Design and Fashion', *Parkett* No. 86.
Branden W. Joseph, ' Play and Display', *Parkett* No. 86.
Tom McDonough, ' Shadow Play', *Parkett* No. 86.

2007 Steven Holt and Mara Skov,' Ornament Decriminalized.' *I.D.* (March/April) 44-46.
Josh Siegel, ' Projects 84: Josiah McElheny', curatorial text for the Museum of Modern Art, New York.
Josiah McElheny, 'Interior Rapport: On Josef Hoffmann', *Artforum* (February) 111.
Josiah McElheny,' Readymade Resistance', *Artforum* (October) 327-335.
Michelle Kuo, 'Industrial Revolution: On the History of Fabrication', *Artforum* (October) 306-314.

2006 Baume, Nicholas (ed.), *Super Vision*, (Boston: Institute of Contemporary Art, Cambridge: MIT Press).
Gregory Volk, 'An Infinity of Objects', *Art In America* (October)166-169.

2005 Scott Rothkopf, Scott and Josiah McElheny, '1000 Words', *Artforum* (November) 236–37.
Helen Molesworth (ed.), *Part Object Part Sculpture*, (Columbus: Wexner Center for the Arts and The Pennsylvania State University Press). Texts by Briony Fer, Rachel Haidu, David Joselit, Rosalind E. Krauss, Helen Molesworth, and Molly Nesbit.
Bruce Sterling, 'Chromified Blobjects', *Blobjects and Beyond: The New Fluidity in Design*, (San Francisco: Chronicle Books) 129.

2004 Josiah McElheny, 'A Short History of the Glass Mirror', *Cabinet Magazine* No.14: 56.
Josiah McElheny, 'Proposal for Total Reflective Abstraction', *Cabinet Magazine* No. 14: 98–100.
Josiah McElheny, 'Useful Noguchi', *Artforum* (November) 176–9.
Josiah McElheny, 'Invisible Hand', *Artforum* (Summer) 209–10.
Elissa Auther, 'The Decorative, Abstraction, and the

Hierarchy of Art and Craft in the Art Criticism of Clement Greenberg', *Oxford Art Journal* No. 27.3: 339–64.

Tom Eccles, Anne Wehr, and Jeffrey Kastner, (eds.), *Plop*, (New York: Merrell in association with Public Art Fund). Texts by Dan Cameron, Tom Eccles, Jeffrey Kastner, Katy Siegel and Anne Wehr

Printemps de septembre à Toulouse 2004 – Volume 1, 'In Extremis', (Toulouse: Les presses du réel).

2003 Melissa Gronlund, 'Reviews: Josiah McElheny', *Contemporary Magazine* No. 52: 71.

Louise Neri, 'Josiah McElheny', Louise Neri, (ed.), *Antipodes: Inside the White Cube*, (London: White Cube Gallery) 38.

Erica Olsen, (ed.), *Warped Space*, (San Francisco: Wattis Institute, California College of the Arts).

Barbara Pollack, 'Beyond the Looking Glass', *ARTNews* (December) 106–9.

Roberta Smith, 'Multiple Realities Clash in a World of Shimmering Reflections', *The New York Times* (11 April).

Traces of Light (Santiago de Compostela, Spain: Centro Galego de Arte Contemporánea).

2001 *Beau Monde: Toward a Redeemed Cosmopolitanism*, (Santa Fe: SITE Santa Fe). Text by Dave Hickey.

Jessica Bradley and Gillian MacKay, (eds.), *House Guests: The Grange 1817 to Today*, (Toronto: Art Gallery of Ontario). Texts by Jessica Bradley, Charlotte Gray, Gillian MacKay, and Jennifer Rieger.

Kathryn Hixon, 'Glass, Apprenticeship, and Josiah McElheny', *New Art Examiner* (February) 72.

2000 *2000 Biennial Exhibition*, (New York: The Whitney Museum of American Art).

William Wood, 'Access Codes and Avoided Objects in the Work of Brian Jungen, Josiah McElheny, and Cornelia Parker', *Parachute* 99.

1999 Sarah Greenberg, 'Artist profile: Josiah McElheny', *The Art Newspaper* (8/9 February) 23.

James Rondeau, 'The Artist in the Museum: Infiltrating the Collection', *Sculpture* (July–August) 25–8.

1998 Joe Scanlan, 'Reviews: Josiah McElheny', *Frieze* (January–February) 92.

Gregory Volk, 'Reviews: Josiah McElheny at AC Project Room', *Art in America* (March) 107.

1997 Jerry Saltz, 'Reviews: Josiah McElheny',*Time Out New York* (30 October) 42.

Roberta Smith, 'Art in Review: Josiah McElheny', *The New York Times* (17 October).

1996 Tim Yohn (ed.), *A Labor of Love*, (New York: The New Museum of Contemporary Art). Text by Marcia Tucker.

1995 Bob Goldfarb and Mimi Young (eds.), *Temporarily Possessed*, (New York: The New Museum of Contemporary Art) 127, 159.

Roberta Smith, 'Art in Review: Josiah McElheny and Dan Peterman', *The New York Times* (10 February).

right and overleaf:
Installation view:
Josiah McElheny
The Past Was A Mirage I'd Left Far Behind, 2011-12
Research material

Observing Abstraction

A History of Abstraction in Film

Poet **Kenneth Goldsmith** was invited by **Josiah McElheny** to select films to be projected onto his sculptures. Goldsmith is the founding editor of the web-based, educational archive UbuWeb.

"While UbuWeb hosts a lot of abstract films, it's a history I'm perhaps too familiar with. While I adore them, when asked to curate a selection, I find myself pulled more toward abstract films with a twist, a nod, and a wink; ones that are wholly aware of the history they're involved with, yet tend to subvert – and thereby extend – that history.

I think a key example of this is **Peter Gidal's** *Clouds* (1969). It's ten minutes of atmosphere, with a tiny aircraft occasionally puncturing the pictorial space. Most of the film is insanely ambient, but those small moments of representation narrativize the long stretches of abstraction.

Similarly **Karel Dodal** and **Irena Dodalova's** *Hra bublinek* seems at first to be a classic work of abstract animation, but halfway through, the abstractions align and form a bar of soap; you realize that it's all merely a set up for a soap ad. Brilliant.

Lillian Schwartz's *Pixillation* was made in 1970 but it feels like it could've been made tomorrow. Digital pixels form into patterns that look like a cross between Navajo rugs and James Siena paintings, accompanied to an early computer soundtrack by Space Age Bachelor Pad Music composer Gershon Kingsley. Schwartz's film unintentionally feels like a bad screen saver, which is exactly what **Jeremy Blake** intentionally does three

decades later with *Liquid Villa* (2000), ironically referencing the empty ambiance of the computer screen. And then think of are abstract films which make you see everyday life differently.

Ernie Gehr's *Serene Velocity* (1970) haunts me every time I walk down a hallway of any number of postwar NYC apartment buildings. By repeating a short clip of film of a banal hallway over and over again the representational morphs into the abstract, resulting (like Kubrick's hallway in "The Shining") in a terrifying transformation of the banal into the iconically psychogeographic."

Kenneth Goldsmith, 2011

Films

Conversations with History

'So either you can believe there is this thing called history which is a linear narrative or in some general sense a linear narrative with a definable kind of thrust to it, or you could say that there's just a lot of different stories.'

Josiah McElheny, 2010

Reflection

'If "the reflective" can be described as a medium, it is one in which the viewer becomes the author, because without the viewer it is impossible to discern the something, or even the nothing, that is there.'

Josiah McElheny, 2004

Acknowledgements

The Whitechapel Gallery thanks its supporters, whose generosity enables the Gallery to realize its pioneering programmes.

with support from

Bloomberg

Bloomberg's support reflects its commitment to innovation, and its ongoing efforts to expand access to art, science and the humanities.

Wingate Scholarships

The exhibition catalogue was made possible by White Cube, London, and Andrea Rosen Gallery, New York.

**Whitechapel Gallery
Director's Circle**

Shane Akeroyd
Cranford Collection, London
Joseph and Marie Donnelly
Maryam & Edward Eisler
Fares & Tania Fares
Noor Fares
Philippe & Zaza Jabre
Edward and Agnes Lee
Yana & Stephen Peel
Catherine & Franck Petitgas
Maya & Ramzy Rasamny
Maria & Malek Sukkar
and all those who wish to
remain anonymous

**Whitechapel Gallery
Exhibition Patrons**

Clarence Westbury Foundation
Haro & Bilge Cumbusyan
Carolyn Dailey
Sarah & Louis Elson
Leili Huth
Peter & Maria Kellner
Maha Kutay
The Loveday Family
Mundus Imaginalis Collection
Adrian and Jennifer O'Carroll
Pascale Revert & Peter Wheeler
Renee and Mark Rockefeller
Jonathan Tyler
and those that wish to remain
anonymous

**Whitechapel Gallery
Patrons**

Charlotte & Alan Artus
Nasser Azam
John Ballington
Arianne Braillard & Francesco
Cincotta
Emanuel Bregin
Hugo Brown
Carlo Bronzini Vender
Debbie Carslaw
Sadie Coles HQ
Swantje Conrad
Alastair Cookson & Vita Zaman
Donall Curtin
DunnettCravenLtd
Milovan Farronato
Nicoletta Fiorucci
Eric & Louise Franck
Alan & Joanna Gemes
David & Susan Gilbert
Louise Hallett
Isabelle Hotimsky
Cliff Ireton – Willett Kingston Smith
Jerwood Visual Arts
Amrita Jhaveri
Matt & Kate Jones
Phillip Keir
David Keltie
James & Clare Kirkman
Victor & Anne Lewis
Lisson Gallery
Joshua Mack
Daniel McClean
Keir McGuinness
Warren & Victoria Miro
Mary Moore
Dominic Morris & Sarah Kargan
Mummery + Schnelle
Angela Nikolakopoulou
Simon Oldfield Contemporary Art
Maureen Paley
Dominic Palfreyman
The Porter Foundation
Jasmin Pelham
Tim Rich
Jon Ridgeway

Published on the occasion of the exhibition:

The Bloomberg Commission: *Josiah McElheny: The Past Was A Mirage I'd Left Far Behind* Whitechapel Gallery, London 7 September 2011–20 July 2012

Exhibition
Curator: Daniel F. Herrmann
Research Assistant: Habda Rashid
Exhibitions Trainee: Priyesh Mistry
Installation: Chris Aldgate, Patrick Lears

Publication
Editor: Daniel F. Herrmann
Assistant Editors: Candy Stobbs, Ariella Yedgar
Designed by Mark Thomson
Printed by die Keure, Belgium
Set in LL Brown

Published by the Whitechapel Gallery

First published 2012

© The authors, the artists, the photographers, Whitechapel Gallery Ventures Limited

Whitechapel Gallery is the imprint of Whitechapel Gallery Ventures Limited

ISBN 978-0-85488-201-4

A catalogue record for this book is available from the British Library

Cover image: *Screen For Observing Abstractions No. 6* (detail), 2011

The Artist wishes to thank Susanne DesRoches, Daniel Herrmann, Habda Rashid, Chris Aldgate and everyone at Whitechapel. Thanks to all the collaborators on the project; Bernard Kops, Kenneth Goldsmith, Cheryl Donegan, Richard Johnson, Lisa Le Feuvre, Tamara Trodd, Jemma Read, Lois Stonock, Iain Boyd Whyte as well as all the supporters of the exhibition and its catalogue.

Very special thanks to White Cube, London and Jay Jopling and Craig Burnett; Andrea Rosen Gallery, New York and Teneille Haggard and Renee Reyes; Donald Young Gallery; Daniel McClean; Ashley Elliott and the Whitewall Company; Sue Evans, Rianne Groen, Gary Haines, Zoe McLeod, Marte Paulssen, Cathy Y. Serrano, Maija Siren, and Marta Zboralska.

Copyright and photography

Whitechapel Gallery Ventures Limited
77–82 Whitechapel High Street
London E1 7QX
whitechapelgallery.org

To order (UK and Europe) call +44 (0)207 522 7888 or email MailOrder@ whitechapelgallery.org

Catalogue contributors

Lisa Le Feuvre is a curator and writer on art and Head of Sculpture Studies at the Henry Moore Institute, Leeds, England. She was curator of contemporary art at the National Maritime Museum, London (2005–10) and taught on the postgraduate Curatorial Programme at Goldsmiths, University of London (2004–10). She was co-curator, with Tom Morton, of *British Art Show 7: In the Days of the Comet* (2010–11).

Daniel F. Herrmann is Eisler Curator and Head of Curatorial Studies at the Whitechapel Gallery, London. Previous exhibitions include *John Stezaker* (2010), *'Painter' and The Studio: Paul McCarthy and the Myth of the Artist* (National Galleries of Scotland, 2010) and *Miroslaw Balka: Entering Paradise* (National Galleries of Scotland, 2008).

Tamara Trodd lectures in twentieth century and contemporary art at the University of Edinburgh, Scotland. Her edited book *Screen/Space: The Projected Image in Contemporary Art* was published by the University of Manchester Press in 2011. She writes and lectures widely on art, photography and artists' film.